MASTERING Light & Shade
IN WATERCOLOR

BY ONG KIM SENG AWS, DF, NWS

Sabutu Spring, Bali, 22 x 31" (56 x 79cm)

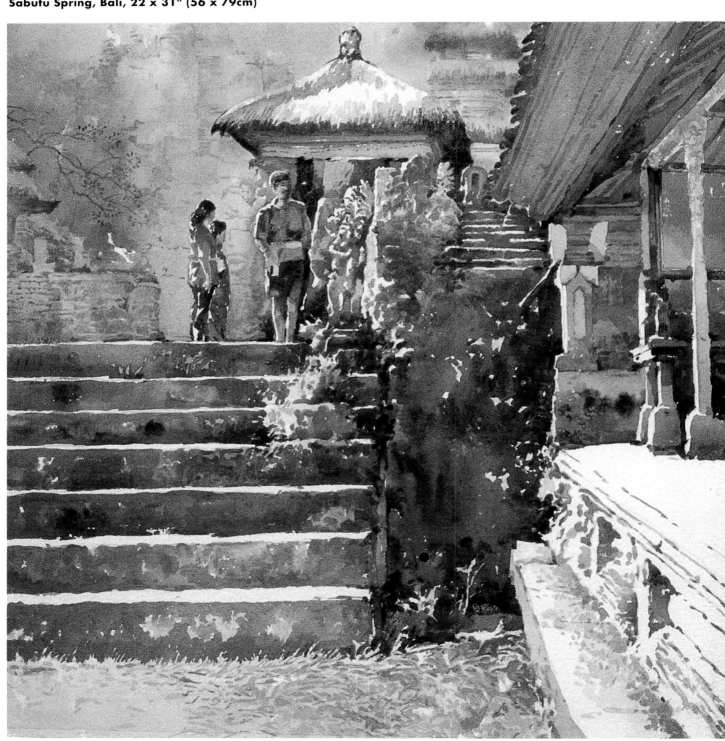

MASTERING Light & Shade
IN WATERCOLOR

BY ONG KIM SENG AWS, DF, NWS

international
artist

international
artist

International Artist Publishing, Inc
2775 Old Highway 40
P.O. Box 1450
Verdi, Nevada 89439
Website: www.international-artist.com

Edited by Terri Dodd
Designed by Vincent Miller
Typeset by Ilse Holloway
Editorial Assistance by Dianne Miller

ISBN 1-929834-23-3

Printed in Hong Kong
First printed in hardcover 2003
07 06 05 04 03 6 5 4 3 2 1

Distributed to the trade and art markets
in North America by:
North Light Books,
an imprint of F&W Publications, Inc
4700 East Galbraith Road
Cincinnati, OH 45236
(800) 289-0963

ACKNOWLEDGMENTS

I would like to thank Teo Boon Guat and Tham Kum Yuen
for their efforts in putting the initial manuscript and
photographic illustrations together. My thanks also go to my
publisher, Vincent Miller, and my editor, Terri Dodd for their
encouragement and confidence in my work.

DEDICATION

This book is dedicated to my wife, Ah Moy, my son Henry
and his wife Sharon, daughters Dora, Diane and her husband
Raymond and little Ryan Kobe.

FOREWORD

I first met Ong Kim Seng at the famous Salmagundi Club in New York in 1983. We were both attending the Annual Awards Dinner of the American Watercolor Society. His watercolor, "Heart of Kathmandu", had just been selected as the winner of the Paul Remmey Memorial Award and Kim Seng had just become the very first Singaporean to receive an award from the AWS. This was to become a familiar scenario. He would continue to be recognized over the next twenty years and would eventually be awarded a Dolphin Fellowship of the Society.

Kim Seng and I have remained in touch since that time, visiting each other's country and painting together on a memorable trip to Europe. His work has continued to grow in stature, bringing honor to his own country of Singapore and enhancing the reputation and status of our beloved watercolor medium itself. His years as President of the Singapore Watercolor Society, together with his work with the Asian Watercolor Confederation, have seen him work selflessly to promote the image of the medium and to raise the standard of watercolor in many parts of Asia, the benefits of which are now being enjoyed by watercolorists throughout the East.

Kim Seng is basically a traditionalist, above all a superb draughtsman possessed of a keen and perceptive eye. However, his technical expertise is never allowed to dominate his painting. It is there to enable him to portray his subject in the way that he FEELS it, not just as he SEES it.

This thought has been forgotten by many of today's younger painters. Because there's so much photorealism they think that unless a painting looks like a photo then it is not good! They may produce very clever reproductions of the subject, but these works are devoid of emotion and personal involvement.

Never does Kim Seng's work convey this sterile approach. The viewer can always feel the artist's sensitivity, his spontaneity and his personal reaction to his subject . . . that's what I believe ART is all about!

Working in the heat and humidity of Singapore presents many problems for the watercolor artist, so my respect for his work grows when I realize the difficulties that must present themselves with every attempt to paint in watercolor. From looking at his works one would never know that these conditions existed. The watercolors seem to have been achieved with such ease — the mark of a master artist.

His skill in handling watercolor, his control while retaining fluidity and freshness, his ability to recognize color and its effect on the mood of his painting, his powers of selection and observation all add up to the fact that I consider Ong Kim Seng to be one of the master painters of watercolor in the world today. I am sure that you will agree with me as you journey through the pages of this presentation of his wonderful watercolors!

Robert A. Wade OAM, AWI (Aust.), AWS (USA), FRSA (Lon.), MHSMA (Mexico)

CONTENTS

INTRODUCTION

LEARN TO CONTROL THE PROCESS AND YOU WILL BE ABLE TO EXPRESS YOUR FEELINGS IN LUMINOUS WATERCOLOR.

I didn't know about watercolor when I first started drawing. I had been using charcoal to sketch until one day I saw an old artist painting a building near my house. He was using colors, so I walked up and asked him what he was using. That was my first encounter with watercolor. I ran home and dug into a box of color given to me by my aunt, that I thought was similar to those used by the artist. I tried mixing them with water in various ways but I just could not obtain the beautiful transparent effect that old artist had achieved. I was puzzled, but there was no one I could turn to for help. Art schools were unheard of in those days but, in any case, I would not have been able to afford the fees even if I could find a teacher. Finally, I went to an art shop in town and asked the owner for help. He solved the mystery for me. He told me that what I thought was watercolor was in reality poster color, so it was no wonder I could not get those transparent effects. That was 38 years ago.

Today, watercolor is my main painting medium. This wonderful and exciting medium has accompanied me to many countries, including my many treks in the Himalayas in Nepal and Tibet. While working with this medium I have also met many artists from other parts of the world.

Watercolor is a very unpredictable medium and each time I paint a scene it is always a challenge. However, I still consider it the most appropriate medium for outdoor painting because the equipment is light and simple, and it can be easily tucked into a bag. My "watercolor bag" has become a part of my luggage on all my trips.

Learning to paint in a crowd

Artists always seem to attract a lot of interested, curious people. Many of them, whether in remote villages or in cities, like to watch us work. I usually regard such occasions as opportunities to study the people in the different places in which I paint. Sometimes these watchers can be a real distraction. When I was painting in Nepal while trekking to the base camp of a 26,240 foot (8,000 metre) mountain, I attracted a huge crowd, including trekkers from other countries. The villagers inspected my brushes and the children touched the stretched watercolor paper I was using. Fortunately, one of the older villagers came to my aid and chased the children away. At other times, I had to resort to bribing children with sweets and other goodies so that I would be left alone to paint. It is difficult to avoid attracting people when painting in more populated areas, but through the years I have developed the ability to endure the discomfort of uncomfortable places, and the stress and pressure exerted by a crowd, and still concentrate on my painting.

Evaluating and relating

For me, watercolor painting is a life-long commitment. This medium pushes me to think and work fast. However, in order to understand the nature of the medium it is necessary to explore the techniques and applications of other experienced artists and how they express themselves in paint.

Many inexperienced artists believe that in their attempts to produce a good painting their primary need is mastery of technique. I think it takes more than technical efficiency to achieve an artistic result. When I settle down to do a painting, I try to relate the painting that I am starting with those that I have done previously, or even with paintings by other artists. This relationship with other paintings acts as a guide when sketching the composition. One of the main decisions to be made has to do with the colors to use — and many color schemes may flash through my mind. Most of the time I try not to go along

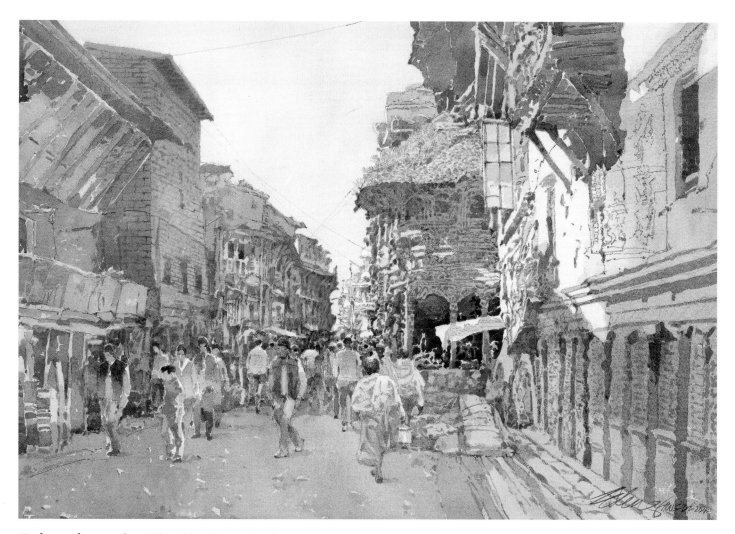

Kathmandu morning, 22 x 31" (56 x 79cm)

with the colors of the actual objects, but put in my own colors according to the atmosphere that I want to create. I tend to use the colors with which I am most comfortable. Thus I set an objective for my painting. I always think beyond the existing scene in terms of color changes and the possible variations in the composition before I begin painting. In this way I can control the painting as I progress. When I am able to control the process, the end result is clearly defined and quite often impressive!

Expressing feeling

Every one of my paintings is an expression of how and what I think and how and what I feel. Before every painting I go through the process in my mind so that the finished work will not merely catch the viewer's eye but will stop them in their tracks —

it will create a reaction in them. In other words, the viewer must be impressed!

In this book I will draw on my many years of personal experience as I show you how I create my paintings. Hopefully, you will gain some useful insights into the captivating art of watercolor so that you too will be able to master light and shade with watercolor!

TOOLS OF
Expression

CHOOSING EQUIPMENT AND COLORS TO SUIT THE CONDITIONS.

Brushes

The equipment for watercolor painting is relatively lightweight. When I set out on a painting trip I pack my equipment in my old medium-sized bag. I bring along a few different size brushes. A #10 pure Kolinsky sable is a real treasure, it is a must because it is useful for all my work. I also take with me #8, #6, #3 and #0 brushes. I only use other size brushes when there is a special need, for instance, when I want to do a flat glaze, in which case I will use a flat brush. When I want to paint a wide area I will use a #12 round brush, or even a larger 2" flat brush.

I use a low-cost, lightweight Korean-made plastic folding palette for both indoor and outdoor painting.

Color

I prefer moist tube colors, but I don't stick with a particular brand because I like experimenting with colors from different companies. Sometimes working with only one brand can create an over-dependence on that brand and if through circumstances some colors are no longer available, this can be very frustrating. Recently, many companies have brought out paints with the term "hue" after the name of the original color. What has to be realized is that these paints are lower-cost alternatives to full strength pigments and when hue colors are mixed with another color, the expected result is different from the mixture achieved with the full strength original color.

My choice of color stems essentially from the sunny landscapes that I paint. Tropical Singapore and the surroundings countries in the region are my main painting haunts. These are all bright, sunlit areas with a constant interplay of light and shadow. A painter's delight! My palette therefore consists largely of colors that produce bright, warm and cheerful landscapes, clear skies, lush greenery and stark shadows.

"My palette consists largely of colors that produce bright, warm and cheerful landscapes, clear skies, lush greenery and stark shadows."

My usual palette

Reds: Bright Red, Alizarin Crimson

Oranges: Cadmium Orange, Winsor Orange Hue (which is a weaker replacement for Chrome Orange, which was discontinued because of its lead content.)

Yellows: Cadmium Yellow, Indian Yellow, Lemon Yellow, Raw Sienna and Burnt Sienna

Violets: Mauve

Blues: Manganese Blue, Cobalt Blue, French Ultramarine Blue and Cerulean Blue

Greens: Hookers Green Dark, Permanent Sap Green and Winsor (Phthalo) Green.

Paper

Two of my favorite watercolor papers are: 140lb (300gsm) Schut cold-pressed and 400lb (850gsm) Arches cold-pressed. Although the Schut paper does not withstand punishment like the Arches heavyweight paper, it nevertheless produces certain interesting textures. I also like the dull white of the paper, which does not produce as much glare as other papers when I am painting in the tropical sunlight of Singapore. Painting in the tropics can be a challenge because focusing on an object in the strong sunlight is a strain on the eyes. Even when painting in the shade, the glare is enough to hurt the eyes, especially when making a detailed sketch.

COMPOSITION FOR
Luminosity AND
Contrast

WHEN YOU GET ON LOCATION, SCAN AND QUESTION WHAT YOU SEE. THEN, WHEN YOU ARE READY TO START, MAKE ESTABLISHING THE FOCAL POINT THE FIRST THING YOU DO.

Before deciding on a scene to paint I usually scan the area and ask myself some questions: What draws me to this scene? What is it in this scene that I want to paint? What can I convey that will impress the viewer about this scene? Am I satisfied that I will be able to produce a good painting from this scene?

I also seek out the most interesting object, or rather, the point of interest in the scene. This will be my focal point. It is like planning a story line and working out what the climax will be first. After deciding on the focal point I look at the supporting elements that surround the main object. These surrounding elements should lead the viewer's eyes to the focal point in the painting.

Action Plan!

1. Set and emphasize the focal point.

2. Identify the darks and the lights.

3. Establish the contrasts.

4. Use white space to support the composition.

The composing process

The composition aspect of a painting is very important. When I observe a scene I imagine the finished painting before I begin the actual process of sketching and painting. This is the moment I identify the darkest and the lightest points of the scene in order to establish the contrasts. Once contrast placement has been decided I start to sketch with a pencil, or more often with a small brush dipped in a watery Raw Sienna. I prefer using the brush because it produces a softer sketch as opposed to the harder black lines of the pencil. While sketching the scene I eliminate elements that obstruct the focal point to achieve the scene that I want to see.

My method of leaving space is inspired by Chinese painting and it helps to draw the viewer's eye to the area of interest. Sometimes I create a space in front of the main subject and at other times I leave a space behind the focal point. This sense of space is achieved by using pale colors or by leaving the white of the paper unpainted, an advantage of watercolor painting.

Composition is very important to my painting because it is the key to color blending, balance, as well as the techniques of painting. If a particular composition does not result in a painting that impresses me, then I abandon it because I believe that I have to impress myself first before I can hope to impress others. □

The wisteria, umbrellas and woman buying bread became the focal point of the painting.

To emphasize the strong sunlight I left the two umbrellas white. This directly added contrast to the painting and as a result linked and balanced the two buildings.

I added the details of the two stone buildings in areas nearer to the two umbrellas to help draw attention to the focal area.

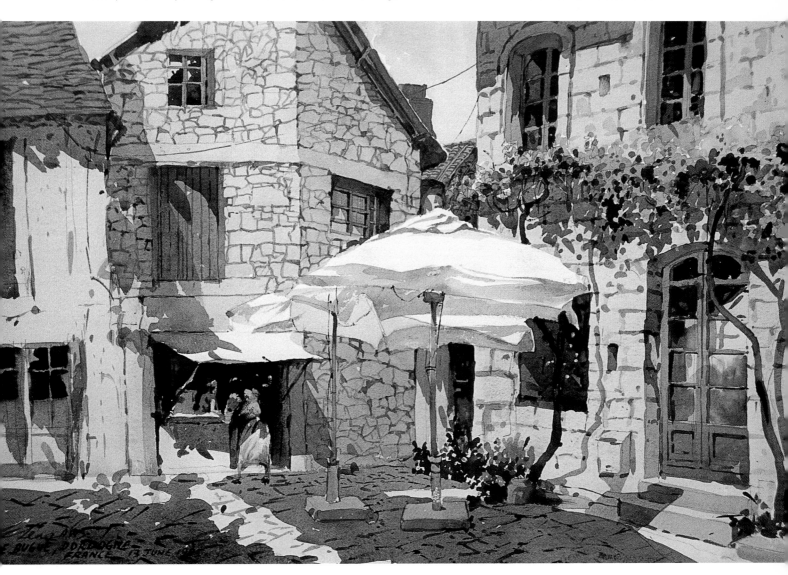

Working with darks and lights to emphasize the focal point

Le Bugue, Dordogne, France, 15 x 22" (56 x 79cm)

I wanted to capture the sunlight in this painting and at the same time show the wisteria creepers on the building on the right.

I used a heavier distinct shadow for the ground to show the time of day. The cobblestone walkway was drawn in with fine lines towards the end of the painting. I usually check for details missed out or unfinished when a painting is about to be completed.

Using contrast to lead the eye

Potala, Tibet,
15 x 22" (38 x 56cm)
The Potala Palace, the winter retreat of the Dalai Lama, is the symbol of Tibet.

I climbed a hillock opposite this magnificent architectural wonder to paint its splendor. I like the contrasting red and white of the façade of the building. The Potala is visible from miles away. I painted the palace first to show its importance.

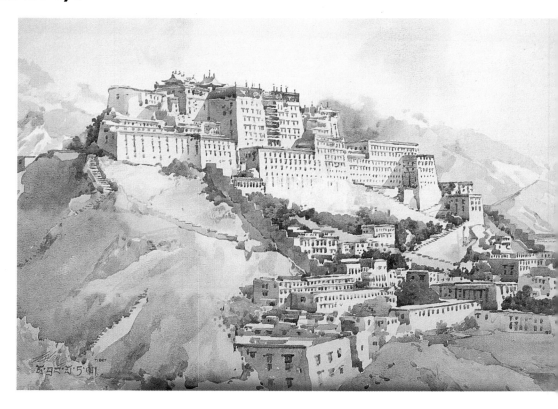

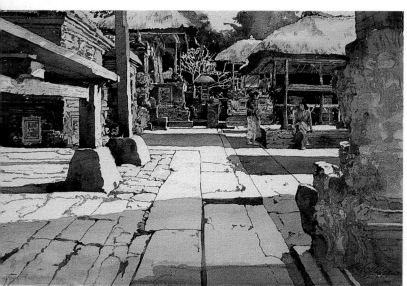

Using line to support the composition

Royal Courtyard, Bali, 22 x 31" (56 x 79cm)
This painting of a royal courtyard in Bali is an example of how I use lines to lead the eye to the center of interest.

The complicated part is centered at the top of the painting, where I left a very narrow area of sky to suggest distance. I used broad brushstrokes for the shadows, which were rendered with a #12 Kolinsky sable. The fine lines showing the cracks in the foreground were drawn with a #3 brush. The focal point, the lady sitting on the center left of the painting, was highlighted with Alizarin Crimson Permanent.

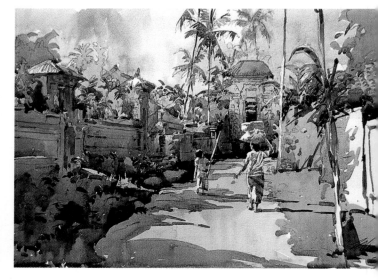

Creating a definite focal point with shadows

Returning from the market, 15 x 22" (38 x 56cm)
Ubud is a small town in the central part of the island of Bali in Indonesia. I captured this scene late one morning. I used a limited palette in a combination of earth colors and greens. I left areas lit by the sun as white paper. To show the time of the day, I emphasized the length of the shadows. The small streak of light on the left showing the half-opened door is important because it allows a breathing space for the areas that are in the dark. In this painting, the focal point is quite definitely the two persons walking towards their house.

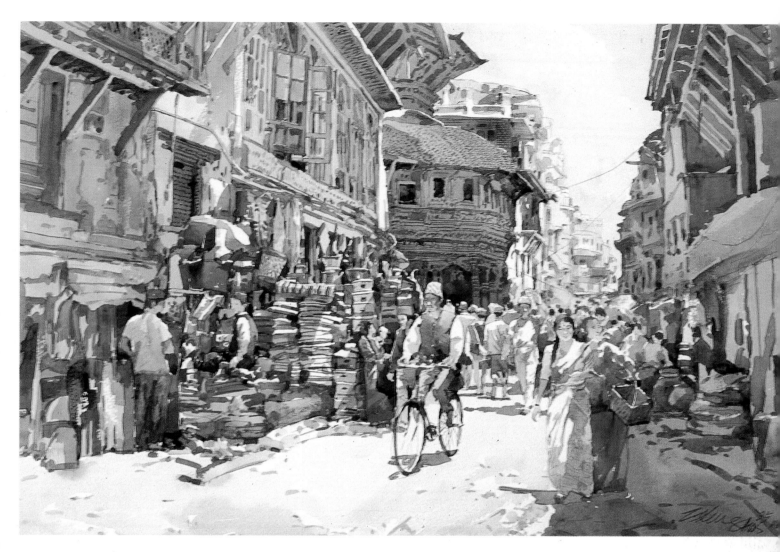

Using line and light for emphasis

Midday in Kathmandu, 22½ x 30" (57 x 76cm)

In my Nepali paintings the wonderful medieval buildings offered ready made subjects. All I needed to do was put emphasis on the point of interest. I love the costumes of the various tribes of Nepal moving about in the streets.

To create activity and movement I used short brushstrokes for the shaded areas and used short washes for the shadows, which were not joined to the outlines of the figures. At the same time I faded out the crowd in the distance.

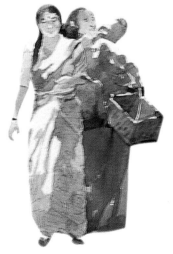

In this painting, the traditional man riding a bicycle looks a little odd, but he is the focal point in the composition.

When I paint a busy street scene, I watch out for traditional dress that I can blend into the scene. I try not to put in too many people dressed in modern-day style when the backdrop is 17th century buildings.

Using restricted colour to lead the eye

Tamang Porters,
22½ x 30" (57 x 76cm)

I painted this scene during one of my treks in the Annapurna region of Nepal. The two Sherpas belonged to a hill tribe and were taking a rest at one of the lunch stops. I like the arrangement of the cut wood drying in the sun which pointed in the direction of the two men, making an excellent composition. To focus on the standing man I painted a darker background around him to contrast with his white shirt. I used dry brush strokes and a restricted color scheme of siennas to show the arid land and to accentuate the mud house.

These people are used to reporters and writers, so anyone scribbling on a pad is nothing new to them. But when they came forward to see what I was "writing", they were surprised to see a sketch of them. They started talking to me in a language that was incomprehensible. Then they changed to halting English to ask for medicine. One showed me an injured foot and the other pointed to his eyes. I gave them some iodine in liquid and tablet form and my spare pair of shoes.

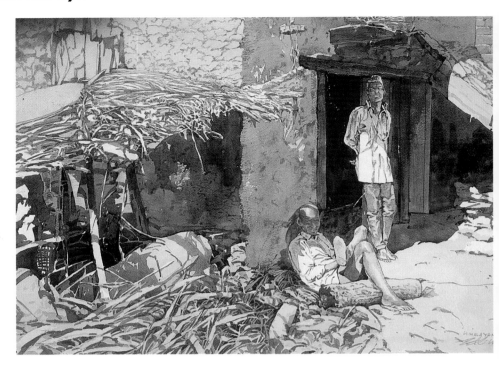

How color helps to balance a composition

Dordogne, France, 22 x 31" (56 x 79cm)

This was the scene from my hotel room in this beautiful country town. It was morning and the houses were lit by a creamy glaze thrown by the rising sun.

Sometimes a composition may be well executed but a painting can still fail because the artist uses poor color combinations.

I worked very fast, beginning with sketching the outline directly with a #3 brush dipped in Raw Sienna. There was a faint deep orange at the horizon making the scene very colorful. This was painted first so that I could work from top to bottom using the traditional method of watercolor painting.

This composition is unusual because there is no space for a breather. Furthermore, there are more roofs than entrances of buildings. I had never done a sketch like this before.

In this case the colors did a lot for the composition. Why? Because the strong colors of the shadows help to balance the composition. Notice how the shadow in the foreground leads the eye to the wall which was left as unpainted white paper.

I used a mixture of Permanent Sap Green and Indian Yellow for the meadows in the background.

Dark green, mixed from Prussian Blue and Hookers Green, was used for the trees to enhance the roofs and the walls.

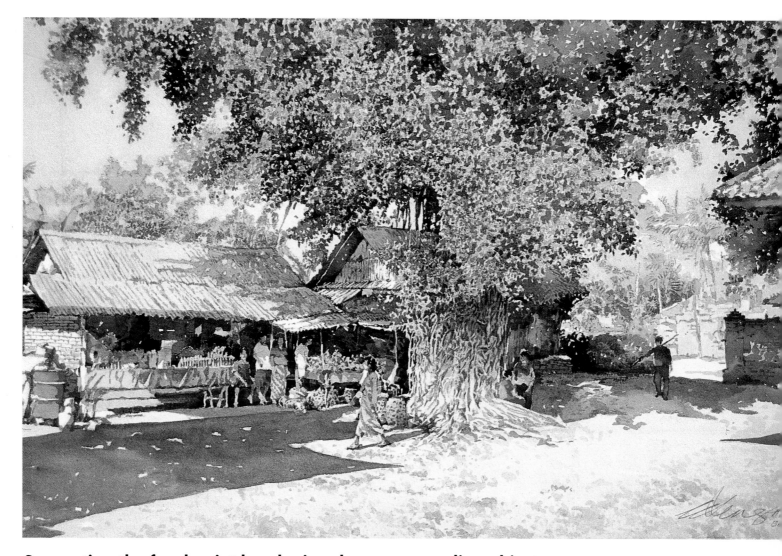

Supporting the focal point by playing down surrounding objects

The Banyan Tree, 22 x 31" (56 x 79cm)

Banyan trees dominate the entrance to most villages on the Indonesian island of Bali. The little inn where I stayed was behind this tree. I loved the shade this gigantic banyan cast and the activities that happened around it. The fruit seller and the Balinese coffee shop beside it offered an array of activities every day. I had tried to paint this scene many times before but each time I had to travel to other parts of the island and the idea was shelved. This time I was staying in the village and I could settle down to paint the scene.

I used a glazing method. First, I took pains to draw the leaves of this majestic tree, then I applied light washes for the trees at the back to throw the main subject more prominently into focus. I used a variety of greens for the trees and the houses creating earthen colors out of Burnt Sienna, Raw Sienna, Ultramarine Blue and Chrome Orange. For the people and fruits sold at the stalls I used bright colors of Cobalt Blue, Manganese Blue, Chrome Orange and Vermilion.

For this painting I used a very heavy rough paper in order to get the textural effect I wanted for the tree and the buildings.

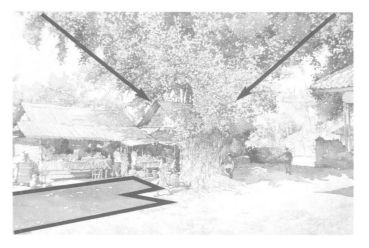

The banyan tree was my point of interest and the shops and people supporting it formed a V composition. To balance the painting I added a shadow from the left, cast by a building which is not in the painting.

Using white to lead the eye to the focal point

Portofino, Italy, 32 x 22" (81 x 56cm)

When I was in Santa Margarita, Southern Italy visiting the souvenir stores, I saw many paintings or photos of an attractive place which I later found out was Portofino, a small sea port on the coast. I simply had to add the place to my itinerary. The buildings were so artistically arranged that I had no trouble getting the composition in place.

I started with the buildings, leaving the forest on the slope to be painted later on. The buildings were painted in many subtle and pleasant colors. I started by using a base wash of light orange mixed with bright red but I left the roofs white. This gave me the option to either leave them white or paint over them with a light color. I paid attention to the windows and canopies below the buildings.

Having finished the buildings, I painted the trees in the foreground and later the sea with the boats and ships.

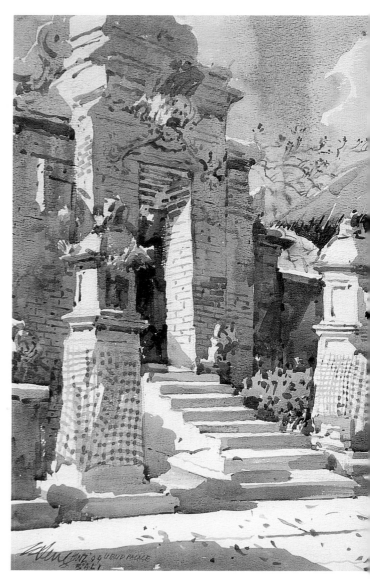

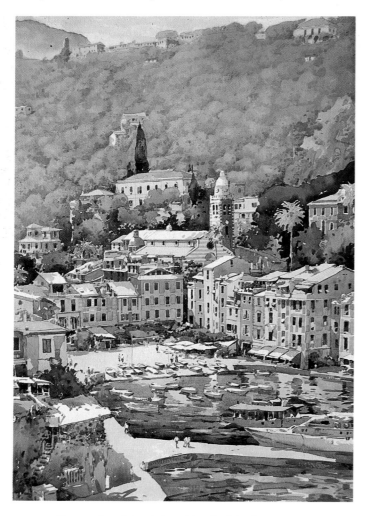

To complete the painting, I finished the forest on the slope with a broad wash of light green. Before it dried, I used a sponge to lift off the areas where I wanted to show the light. When this wash had fully dried, I added a glaze of a darker green mixture of Sap and Winsor (Phthalo) Green for the shadow areas of the trees.

Using texture to lead the eye to the focal point

Palace, Bali, 15 x 22" (38 x 56cm)

A friend once asked me what was so fascinating about Bali that made me go back time and again. I told him that it was the architecture — nowhere else are buildings so well-placed than in Bali. Take Besakih, the mother temple of Bali, for example. This temple is built right at the foot of the active volcano Gunung Agung, creating a natural composition for a painting. Another example, Tanah Lot, the island dedicated to the goddess of the sea, and which houses a temple with two distinguishing pagodas, offers an unearthly landscape in the setting sun. These, and many other examples, have drawn foreign artists and literary scholars to this island, which some have made their home. This painting was done during one of my rest stops.

Techniques for highlighting your focal point

When you are designing your painting consider the following tools to help emphasize your point of interest.

Tone

Color

Contrast

Shape

Size

Line

Texture

Using color to bring depth

Water Village, China, 15 x 22" (38 x 56cm)

This village in Xitang, Jiangsu Province, is famous for its breathtaking scenery. The towns and villages south of the River Yangtze are often praised by poets and writers.

I sat under one of the rain shelters to paint this. Since this scene involved a two-point perspective composition, I decided to create an interesting painting by using colors to bring depth. I also left the center white, because white attracts the eye. Certain areas on the extreme left and right were blurred out by using the wet-in-wet technique. This was done by spraying the area after the first layer of paint had dried.

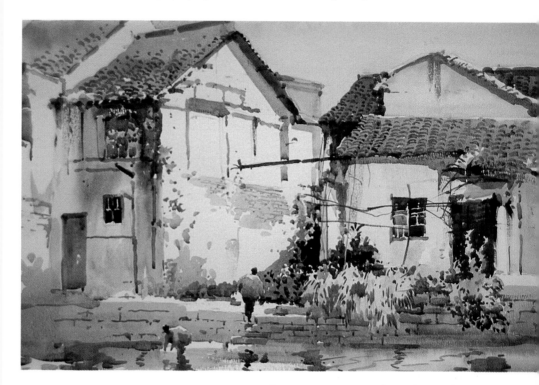

One-point perspective

In one-point perspective only the depth is receding from the picture plane. In this diagram you can see the front of this building is square on with the picture plane, with only the depth of the roof line receding.

Two-point perspective

In this diagram you are seeing the building in two-point perspective because two of its three sides are receding from the picture plane.

Dhaulagiri Massive, 21 x 29" (53 x 73cm)

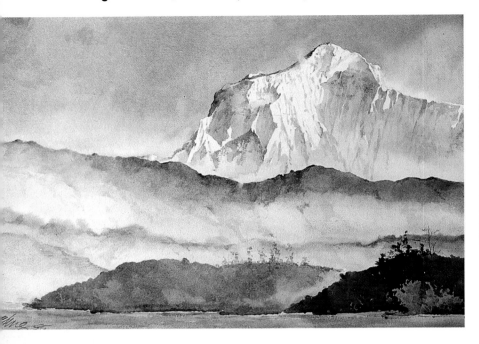

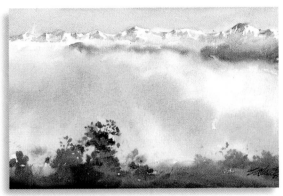

From the foothills of the Himalayas

Using an oriental composition

The Everest Region, Nepal, 22 x 15" (56 x 38cm)

The Everest region in the Himalayas in Nepal is the place of my dreams. I first visited the region in 1978 and was awestruck by its beauty, its lofty peaks, mighty glaciers and majestic monasteries. I was also intrigued by the legend of the Yeti (the Abominable Snowman). One morning I sat down in Tangboche Monastery and painted this mountain and the glacier. I used an oriental composition for the painting and also a very direct contrast of dark and bright subjects. I painted the two mighty peaks of Thamserku and Ama Dablam first, using blues and violet.

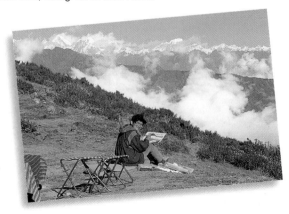

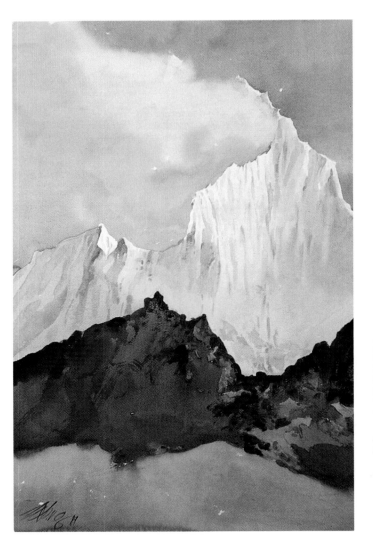

About Oriental Composition

Oriental paintings, especially Chinese and Japanese paintings, are often in the form of scrolls. Since scrolls are long and narrow the placement of subjects in a painting is not easy and requires much thought. In Oriental paintings it is normal practice to have a top-heavy or a bottom-heavy composition.

Composition with color and line

**Himalayan Ranges,
Mount Everest,
22 x 31" (56 x 79cm)**

One day, I saw clouds looming in the distance above the mighty peaks. The scene resembled the zig-zag lines on an electrocardiograph chart. The landscape was predominantly white — the sky was white and so were the snow-capped peaks. At that moment I was undecided about what to do because there was no discernible separation between the clouds and the snow-capped peaks.

First, I painted the clouds using a very light mixture of French Ultramarine and Burnt Sienna, giving them a touch of light grayish-blue at the edges of the snow-capped peaks. I left the peaks white paper. For the fog and mist below the mountain I used the wet-in-wet approach using a darker mixture of French Ultramarine and Burnt Sienna.

This is an example of how a composition involving mainly one color and lines is handled. In this case the clouds and the mountains run parallel to each other. By using different watercolor painting methods I avoided coming up with a dull and flat composition. Tone and color also form an important part of composition. In painting the main peak, Mount Everest, I painted some dark rocks nearer to the summit thus showing the face of Everest as the focal point.

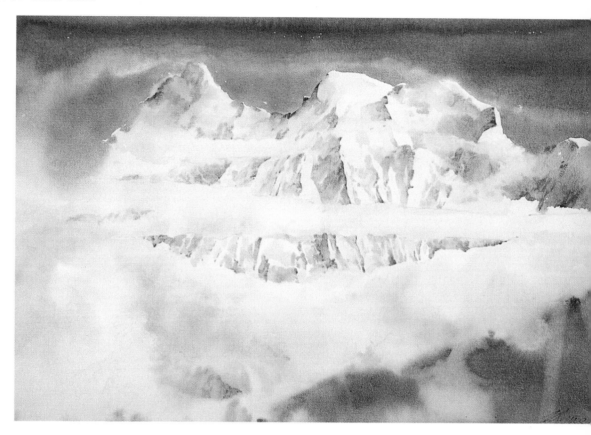

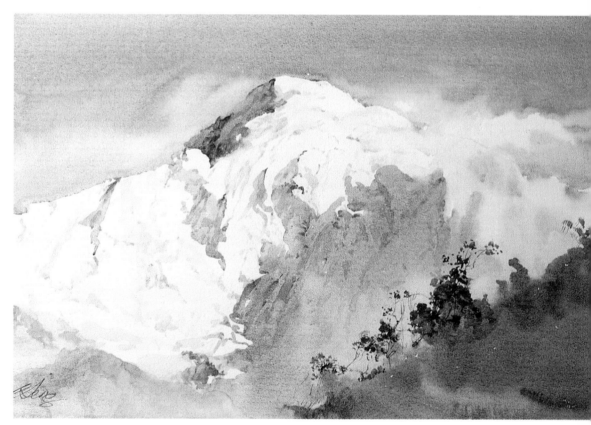

Peak, West Nepal, 21 x 29" (53 x 73cm)

EXPRESSION WITH Color

MANIPULATING LIGHT AND
COLOR TO ATTRACT THE EYE.

When I was very young, I remember being impressed by the transparency and freshness in the watercolor paintings of one of Singapore's masters, Lim Cheng Hoe. He was an expert at painting the Singapore River. His fluid brushstrokes and confident glazes were symbols of his mastery of the medium. Inspired, I tried my hand at color mixing, first, with colors gathered from mud and stones after heavy rain, and later with poster colors. Naturally, none of these worked to give me the beauty and clarity of conventional watercolor! Now I know better — I understand the pigments and how to use them to achieve those marvelous qualities of freshness and transparency. If you want to improve you have to do this too.

Action Plan!

1. Arrange colors in the palette from light to dark.

2. Decide a base or key color for the painting and relate other colors to that.

3. Place warm and cool colors to best effect.

4. Mix different darks.

5. Fuse colors on the paper instead of totally mixing them in the palette.

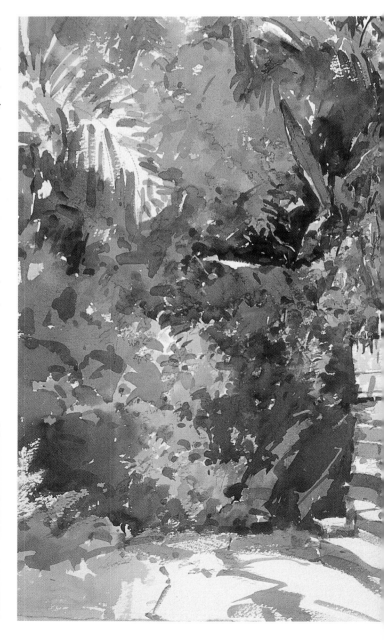

Using color contrast for effect

Village in Peliatan, Bali, 22 x 31" (56 x 79cm)

This scene was painted after I visited an artist friend in the village of Ubud. I was watched by a pack of dogs barking from a distance. I often carry some biscuits with me when I paint outdoors, and I gave them a few to pacify them. That stopped their barking and I was able to begin painting.

For a scene like this, I focused more on the building than on the trees. To draw attention to the entrance of the house, I painted the trees in the background with a darker mix of greens. In this way the roof of the gate and the top of the wall became more distinct in the afternoon sunlight. So the two main colors were greens and earth colors and they added strength to the painting. These colors were arranged to directly balance the dark areas in the center.

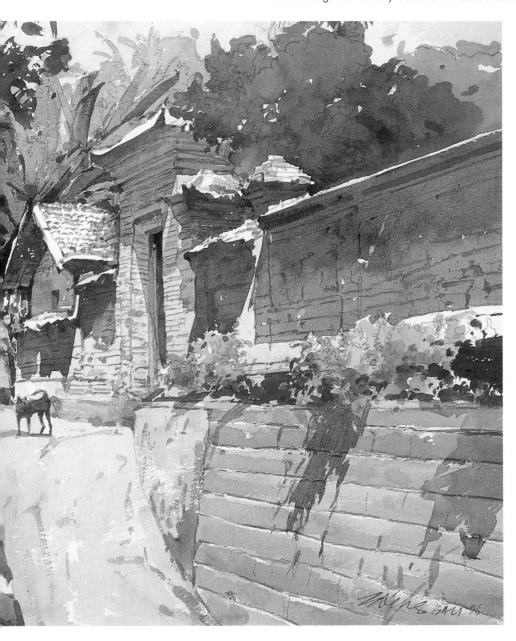

Draw with your brush

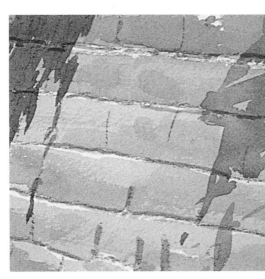

Learn to use brushwork to suggest structure

Working with color

I prefer to use tube colors instead of pan colors because it takes less time to dissolve moist colors from the tube. I can also control my usage by squeezing the amount I need. Another advantage is that I can readily use the moist colors when I want to produce dry brushstrokes.

It is useful to arrange colors from light to dark in the palette, with the lightest color on the left. This allows the lighter colors to flow into the darker ones in case of accidents or when washing the palette.

Every painter has his pet colors and I am no different. I like to use subtle colors. I rarely use pure primary colors unless I want to emphasize and draw attention to a certain area, like clothing or a particular object. Grays and neutrals are important to tone down pure colors, which are seldom seen in reality in nature. Grays also create subtlety in a painting.

Mixing grays

One of my favorite grays is a mixture of Ultramarine Blue and Burnt Sienna. If I need a paler gray I use more water.

For suggesting old algae covered walls, a common sight in tropical regions, I often mix a Raw Sienna with Permanent Sap Green. I fuse this algae green with a mixture of Burnt Sienna and Cadmium Orange for areas not affected by algae. Then, using a dark mixture of Burnt Umber and Ultramarine Blue, I draw the cracks and gaps. In this way a partly algae-covered wall with a weathered effect can be produced.

Working with a base color

To achieve important unity in your painting, choose a base color and relate all the other colors to it. For example, when painting an old rustic town in Nepal I used earth colors as a base and mixtures of Raw Sienna, Burnt Sienna, Yellow Ochre, Burnt Umber, Cadmium Orange, Permanent Sap Green, Ultramarine Blue, Cobalt Blue and Bright Red for the whole painting.

Mixing darks

I do not always observe the traditional English practice of painting from light to dark. Some of my paintings are painted from the darkest part of the scene first. The purpose of this is to establish a dark focal point right at the start. Getting the dark colors right can be very tricky at times because it requires a dark color that is clean as well as fresh in order to prevent a muddy finish.

The aim is to mix two colors accurately without having to paint another layer of dark color over the first dark layer because it is not sufficiently dark. I do this by mixing concentrated Ultramarine Blue with Burnt Umber in equal proportions of pigment and water.

I often use this dark when I want to put a cool color in a spot I want to project. And I use this dark when my painting is bluish in tone and the painting is a concentration of cool colors.

On other occasions, I obtain a dark color by mixing Alizarin Crimson with Hookers Green Dark with an equal amount of water. The result is a very dark red which I use for warmer paintings with mixtures of reds and oranges, for example, a hot sandy landscape on a sunny day. I also use this mixture for my tropical scenes of Malay villages and the streets of Nepal. At other times I use this dark for interiors of shops and buildings, and for objects such as jars, containers, holes in the ground, and so on.

Ultramarine Blue and
Burnt Sienna

Raw Sienna and
Permanent Sap Green

Ultramarine Blue and
Burnt Umber

Alizarin Crimson and
Hookers Green Dark

Using stronger pigment for emphasis

**Bhaktaphur Museum, Nepal,
31 x 22" (79 x 53cm)**

I always visit the old city of Bhaktaphur when I visit Nepal. Almost all the buildings are earthen red and strong in foundation. This scene is part of the oldest part of the town called Tachupai Tole, or Dattatraya Square, and dates back to the 14-16th centuries.

I painted the temple in the foreground before the main museum building at the back of the painting. Stronger and darker siennas and reds were used for the foreground subjects, and light washes were used for the background and supporting structures. In this way the focal point, the temple and the woman in the foreground, were clearly defined.

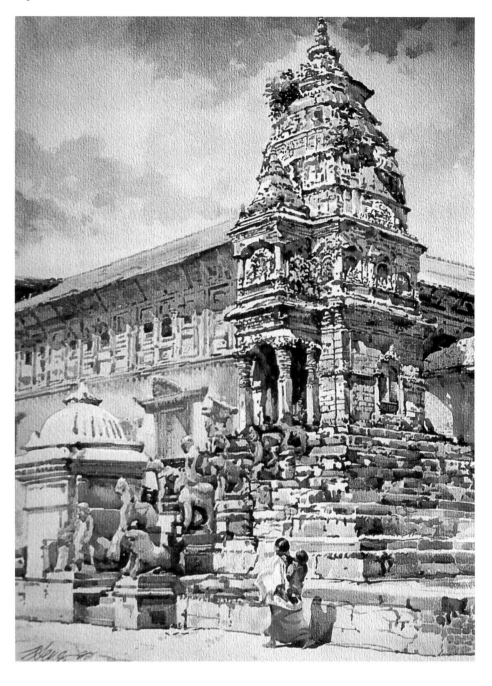

I concentrated on the woman walking and the monument on her right, using the wash and glaze techniques for these.

"The ability to use colors effectively to reveal the emotional message of a painting contributes much to its success. I place importance on color to achieve the clarity and transparency that I believe are only possible in this medium."

Fusion

Fusion is a technique I use frequently in painting. Fusing two colors produces an interesting combination without the distortion of hard edges and water marks that very often occurs when you apply glazes. This technique is very useful when I want to produce paintings with a moody effect or atmospheric conditions.

When I need to paint the horizon line, whether it is for the land or sea, I use this method of fusing two colors. When the colors of the sky are still wet, I apply new colors (which are premixed on the palette) at the point where the sky meets the sea or hills. This resulting fusing enhances the sense of distance without creating hard edges. □

Manipulating whites and bright color to attract the eye

**Melaka, Malaysia,
22 x 31" (56 x 79cm)**

Historic Melaka in Malaysia has managed to maintain its ambience despite other areas developing and modernizing. My hope is that conservation will do justice to the original architecture and color.

This painting was done in the morning during a stopover while driving to see my daughters in Kuala Lumpur. The point of interest in this painting is the house, which was left white. To enhance the light on the house, I applied shadows on the right which indirectly lead the viewer's eye to the brighter objects on the left. To create activity, I added a few people walking towards the center of the painting.

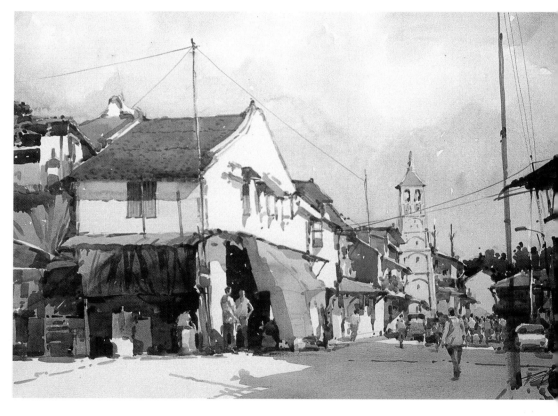

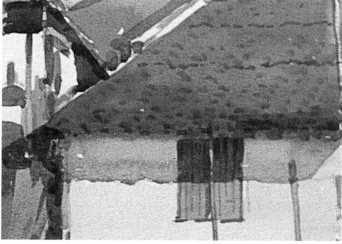

Detail

Detail

26

Using tonal color for emphasis

Sorrento Café, Italy,
15 x 22" (38 x 56cm)

This painting was done very fast in less than an hour. Some may call it a watercolor sketch. I was entranced by the rich colors of the Mediterranean summer, the rich orange wall of the café and the lush green of the palm trees and well-laid garden.

I left the bench white paper in order to lead the eye to the door of the café — the focal point. The door frames were painted a dark green, consisting of Hookers Green and Ultramarine Blue.

I left a white line beside the lady standing near the door to show the open space behind the building. For the shadows I used fast strokes, using the same method as for the leaves of the palm trees to reflect the image of the palms.

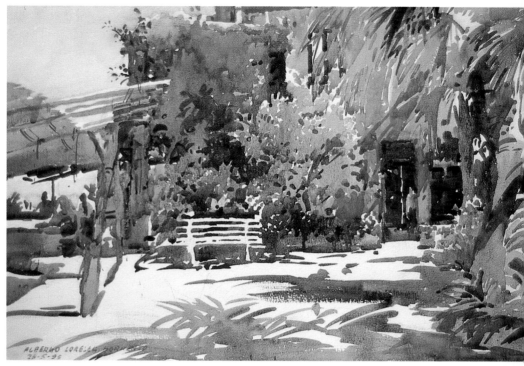

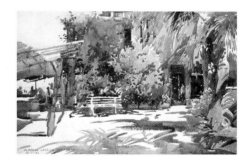

Tonal color plan
Color has tone. This mono version shows how effective my tonal arrangement was in leading the eye to the focal point.

Achieving mood and atmosphere with color

Midday at resort in Bali,
22 x 31" (56 x 79cm)

This was the view from my balcony on a stopover in Puri Indah, Peliatan in tropical Bali. It was very hot outside so the place was deserted. The scene reminded me of those Carribean Island scenes by Winslow Homer.

I made a quick thumbnail sketch to establish the colors before I embarked on this painting.

Although it is a simple painting, one can imagine the hour of the day and almost feel the heat. Most parts of the painting were done with cool colors except for the red flowers — a mixture of Chrome Orange and Vermilion — which I used to project the focal point.

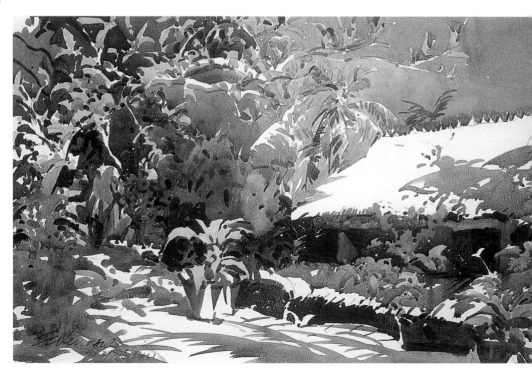

Applying layers of color

**Baynac, France,
15 x 22" (38 x 56cm)**

I never understood the splendor of
Paul Cezanne's colors until I saw
these scenes in Southern France.
It was like walking into a painting
by that great artist. I was very
excited. I worked very fast with a
few brushes, #10, #7, #6 and #3.
I sketched the outline in a neutral
Raw Sienna with a no. 3 brush.
On the palette I mixed a light
green mixture of Lemon Yellow
and Sap Green and for the base
color of the buildings and the hill
I used a mixture of Raw Sienna
and Chrome Orange. When the
base color was still wet I added
the green I had mixed in the
palette earlier on. I painted the
castle roofs and the houses with
a Chrome Orange and Vermilion
mixture.

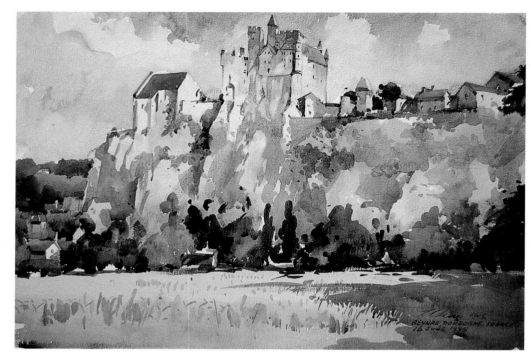

For the second layer of colors,
I observed the texture of the hill
and the weathered surface of the buildings. I found the natural
colors there distinctly richer — the reason why European artists have
such rich colors for their landscape paintings. After the colors had
dried, I painted the details of the castle and the houses which I had
been studying for a while. The castle and hill were prominently
depicted because this is the focal area.

Using color to advantage

Alkaff Mansion, Singapore, 31 x 22" (79 x 56cm)

The Alkaff family owns this magnificent building on top of a hill
which is part of the Mount Faber range in the southern part of
Singapore island. The building was renovated and refurbished into
a restaurant. Like many beautiful buildings in Singapore, overgrown
trees hide the best views of this building from visitors and painters.
Many trees that were not supposed to be there were either planted
or left to grow freely. I had to walk around the building many times
before I could decide on the best angle for a painting.

In this painting I projected the scene by using contrasts of color
and tone to bring out the vegetation and the building. The footpath
and the steps lead the eye to the mansion where two figures are
seen coming down the steps. I made these figures up to create
interest in a not too exciting scene.

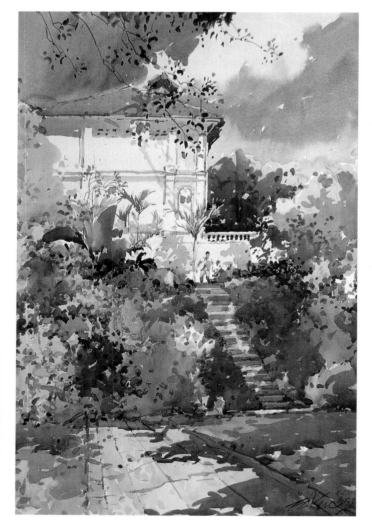

Detail

Detail

Creating a point of interest

**Kampong, Singapore,
15 x 22" (38 x 56cm)**

In Singapore in the 1960s there were many *kampongs* (squatter areas) inhabited by the Malay community. When I was a child I had to walk past a huge kampong on my way to school. Now the kampong has made way for government housing where different races live together in flats.

When I painted this many childhood memories came flooding back. I left some white paper for the planks on the side of the house. For the main base color scheme I used a diluted dull Lemon Yellow. To show that this was the tropics, I added some coconut leaves.

I wanted the two men to be the focal point so I painted a dark tone shadow on the foreground and used a deeper tone for the doorway to enhance the white shirt.

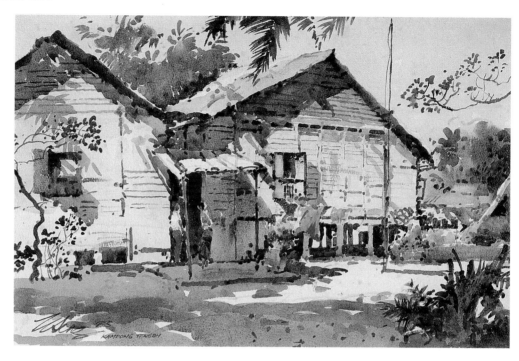

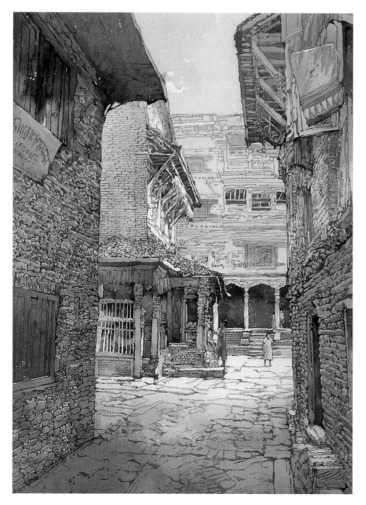

Using captivating earth colors

Ancient Road, Nepal, 31 x 22" (79 x 56cm)

Even though I have been to other parts of the world I have never come across a place with colors that suit my taste so much as Nepal. Its captivating earth colors draw me like a magnet. Many artists have their pet colors and I am no exception.

I like painting familiar scenes. I composed this one with ease using the lady in red as the point of focus. The building in the center was painted in great detail leaving the areas surrounding the building white, gradually fusing into light Raw Sienna then Umber before going into the darker colors of Burnt Sienna and Vandyke Brown.

When painting the ground I fused a variety of colors within the wash. I controlled the flow of colors by observing the different tonal values when I added the second wash over the first dry layer. After that using a smaller brush I drew the bricks and the stone paved road leading to the courtyard.

Detail

Detail

Working with a base color

Wharf, Cornwall,
15 x 22" (38 x 56cm)

This is a rare scene I painted of Cornwall in England. I realized with excitement that what I saw in front of me was a real life British watercolor painting. Such was my excitement that it took me some time before I could settle down to paint.

Although the scene was dominated by purples and grays, I mixed a basic wash of not purple, but light Alizarin Crimson mixed with Burnt Sienna. I think I was prompted by my old habit of not resorting to purple as a start. After this basic wash I then added other mixtures of orange with purple and siennas for the houses and boats. Because there was a basic wash of Alizarin Crimson, what was left unpainted was glazed over with a light Alizarin Crimson to create the atmosphere of the wharf at that time of the day.

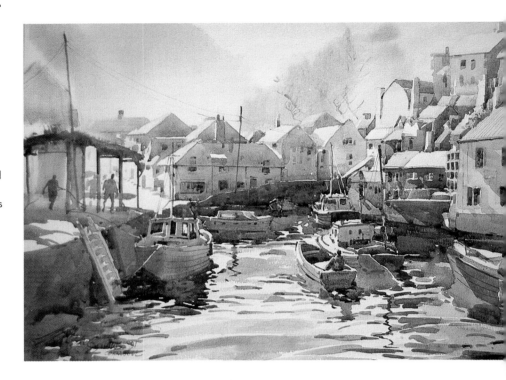

Highlighting the focal point with color

Positano, Italy, 22 x 15" (56 x 38cm)

I will remember this Italian summer all my life. It offered me the best of colors and painting conditions, and as I worked I was oblivious to what was going on around me, even forgetting to be hungry or thirsty. I painted like there was no tomorrow.

My deep emotional involvement in the scene made my work very much easier because I was able to mix colors with great ease. It was all there — reds, yellows, greens, blues — whatever color you like, it was there! That's why choosing a suitable painting place is very important. If you travel thousands of miles to see the same things you have back home, then there is no point traveling all those miles. What we artists want are opportunities to produce different types of compositions and, above all, different colors.

I liked the distant tree-covered hills, which were painted with a profusion of many colors premixed in the palette. I wet the sky area with clear water and then laid in the first wash of color, a fusion of Raw Sienna, Chrome Orange, Violet, Ultramarine Blue and Emerald Green.

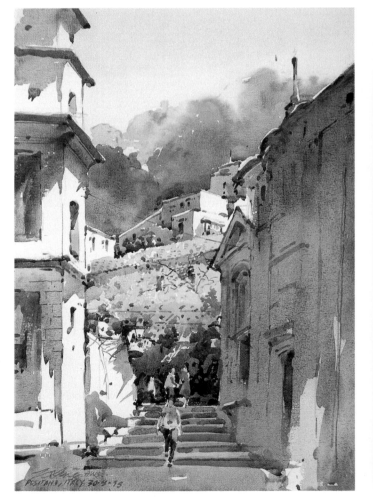

Those multi-colored hills

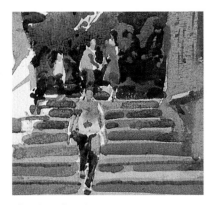

The focal point highlighted with color

Glorious color gives a sunshine mood

**Balinese Village,
15 x 22" (38 x 56cm)**

In Balinese villages, colors abound and it is fascinating to watch the changing hues of the morning. The rich vegetation adds glorious color to the landscape.

I used a light green mixed with Lemon Yellow for highlights on the plants, and Winsor (Phthalo) Green with Ultramarine Blue for the dark areas. For the wall and the entrance I used mixtures of Manganese Blue Hue, Burnt Sienna, Cerulean Blue and Mauve. Highlighted areas on the wall and entrance were left as white paper. The two women are the focus in the painting.

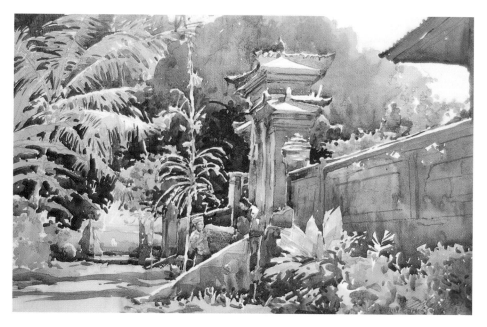

Contrasting warm and cool colors

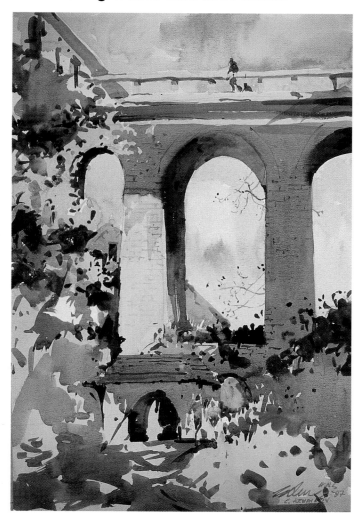

Bridge Crossing, Czech Republic, 22 x 15" (56 x 38cm)

Sometimes situations can be very favorable to the on-site painter. This was the case when I visited the Czech Republic in the summer of 1997. It was my first time in Eastern Europe and I enjoyed seeing many different things — the people, language, weather and most of all, the light.

In Europe I found I could get a distinctive, constant light source, unlike painting in the tropics where a sudden storm cloud during the monsoon can change the much sought after light and shade.

Most of my time at this site was devoted to planning the composition before I began sketching the outline.

I began with the light shades of pale siennas mixed with bright red for the concrete structure, and the little hut below the bridge. To draw attention to the bridge, I painted the trees with different shades of green, giving it contrasts of warm and cool colors.

Detail

Detail

TO MASTER LIGHT YOU MUST MAKE A Shadow PLAN

HOW TO INFUSE YOUR PAINTINGS WITH APPEALING LUMINOSITY AND DRAMATIC CONTRAST.

Action Plan!

- Achieve luminosity and contrast.
- Leave the white paper for the brightest lights.
- Glaze surrounding whites.
- Create strong, rich darks infused with subtle color for the shadows.

I am often attracted by paintings with strong contrasts. And I am not alone in this. When standing at art exhibitions admiring such paintings I often hear other viewers saying things like, "Look at that dynamic picture!" or, "What wonderful control of colors and distribution of light!" Paintings with strong contrast have a powerful impact on viewers. If you want to hear comments like these being made about your paintings then you must master the light.

The how and why of portraying light and shade

It is how you portray the effects of sunlight that gives a painting its luminosity. Naturally, the sun is also a very important source of light and shade, the contrast, in a painting.

To get the luminosity of a bright sunny day I leave at least 30 to 40 per cent of the white paper untouched. It is not unknown for non-painting friends to look at the blank white paper and ask me whether I have finished painting the picture! Leaving the areas in sunlight as untouched white paper is a very old traditional watercolour technique. The difficulty is knowing when and where to leave these "whites". If you do not tackle this issue at the beginning, before starting the painting, you will fall into the predicament of having too many unpainted or undefined areas.

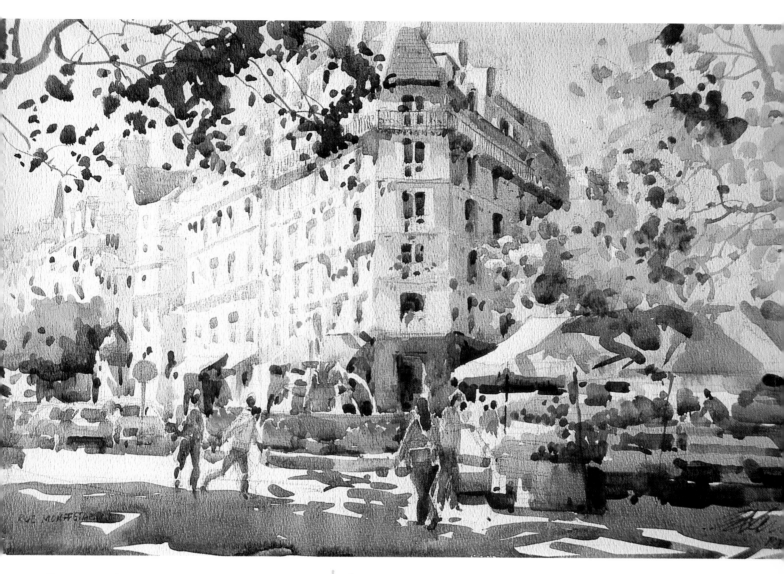

Making a shadow plan

Flower Market, Paris, 15 x 22" (38 x 56cm)

When I am painting outdoors I spend a fair bit of my time studying the shadows and sketching their outlines.

Light conditions change very fast, faster than a brush can paint them, so a better weapon in these circumstances is a pencil shadow plan. When I find an interesting area of light and shade, I quickly whip out my pencil and make a small, preparatory sketch. This can be very helpful when the light and shade suddenly change.

In this painting, the contrast of the shadow on the building is very distinct, so I kept the left side white for the lighted areas. That made me decide to project the area around the balcony, and the person near the stall, as my focal point.

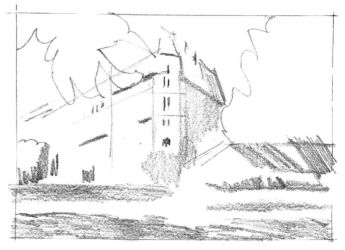

Shadow plan

33

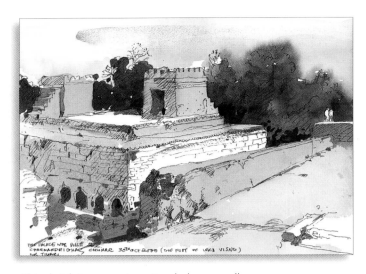

This sketch incorporates a tonal plan as well.

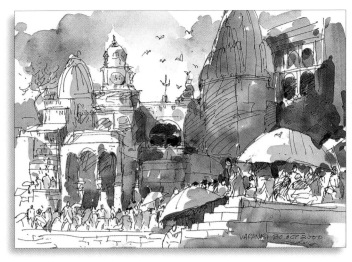

Complex scenes can be made simpler by linking areas into larger shapes of color.

Why light and shade suggest depth

To achieve a convincing three-dimensional effect in a painting, the contrast areas must be accurate and well designed.

When I am painting on site, I often squint my eyes at the scene to identify the bright areas before I sketch the outlines. Sketching outdoors is best done in the morning or at dusk when the sun's rays are at an angle of about 45 degrees.

To paint an effective display of sunlight, it is advisable to choose a location where there are distinctive shadows so that the lighted areas are clearly defined. But not too clearly. For instance, I suggest you avoid painting from a dark corridor into a bright opening because this kind contrast is too sudden. As well, the two contrasting areas are almost equal and your painting will suffer as a result.

Even a quick line drawing like this allowed me to work out the areas of shadow.

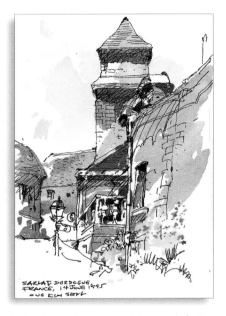

A simple wash takes the idea much further.

Different places — different types of light

When I began traveling I soon found that the light is different in different countries. For instance, the sunlight in Singapore, where I live, is not very intense because of the heavy cloud cover. The flat light there is not significant in terms of giving shape, texture and color. When I visited the Mediterranean countries in summer, I discovered that the light was much different — it was the sky depicted in the paintings of the Italian Masters. The colors of the vegetation and the sea were much richer and the contrasts greater. Getting richer colors and

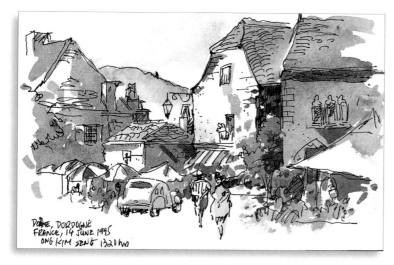

This plan shows the areas I may reserve as white paper for the lightest highlights.

A complex scene needs a detailed shadow plan.

using a wider variety of hues seemed much easier during location painting than when painting back home. Later it occurred to me that to make an eye-catching painting the brightest area of light must be adjacent to an area of dark, or a darker color.

The tonal value of the dark area depends on the intensity of the brightness and in turn the brightest area should be enhanced by the darkest area of the painting.

For example, when painting the light effects of a setting sun, the brightest spot is the sun, so anything that surrounds the sun should be darker. In this case there would be a gradual change in color density, so I would apply a different range of colors, from bright lemon yellow to light orange, then dark orange to dark red and purple. The light colors should radiate out from the sun.

Using the right glaze can enhance the light

To ensure that the brightest point of the main focus is white, I apply a glaze (a thin wash) of very pale yellow over the areas that I have previously left white. This glaze needn't be yellow and can vary with the scene and the time of day. For instance, if it is a painting with a base color of green, then the color of the glaze should be pale green instead of yellow. Deciding on the color to paint over the areas left white is very important because once an unsuitable glaze is added, there is little room for correction.

I carry small pieces of watercolor paper on which I test colors to match the base color. What I do is mix a color that suits the general scheme of the painting. I make sure that there are not too many areas with equal light intensity or the painting will either look flat or, worse, unfinished.

When on site — stick to your original light and shadow plan

Painting in an unpredictable tropical climate can be fraught with hazard because within half-an-hour one can experience sunshine as well as rain. And that's not all — the direction of the light changes too.

To prepare for the worst I always sketch and mark out the light area while the weather is still good. However, at times I get carried away by the scene, and forget to follow the initial outline drawn according to the original light source. The result is a shadow or an area of white in the wrong place! So, remind yourself not to get carried away by the changes in the light and shade, and stick to your initial outline. □

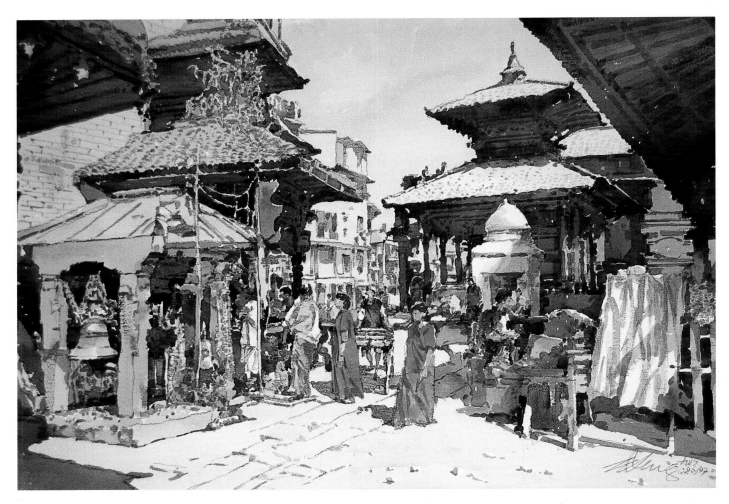

Suggesting atmosphere and mood

Bagamati, Nepal, 22 x 31" (56 x 79cm)

It was late autumn when I stepped into this Hindu temple near the Bagamati River in Nepal. People have often commented that my Nepalese scenes are mostly in earthen colors. My reply is: "Because it's like that", a saying adapting from "Because it's there," a quote attributed to the famous mountaineer Mallory when asked why he climbed mountains.

If you visit Kathmandu today you will feel as if you are walking into a medieval painting, be it in the courtyard of a house of the artist/craftsman Newari tribe, or in a temple. This earthen color is everywhere — on the ground, the roofs and the buildings.

I began this painting by drawing the people first in order to get their placement and the scale and perspective of buildings correct. The two women in the center are the focal point. Near the women, the white altar, which is half lit in the afternoon sun shows the time of day. To project this altar, I mixed a dark color of Burnt Sienna and Ultramarine Blue and a little portion of Alizarin Crimson Permanent.

Shadow plan

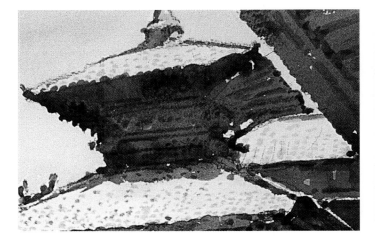

Giving a three-dimensional illusion

Notice how I used shadows and contrast to magnify the illusion of three dimensions. Study the change of planes to see how I did it.

Delineating areas of light and shade

Sabutu Spring, Bali, 22 x 31" (56 x 79cm)

Sabutu is famous for its mineral rich holy spring which attracts people from all over the island to soak or wash themselves. The water used for this painting came from this holy spring, and I think it is for this reason that this painting was accepted for the American Watercolor Society's 128th Annual Exhibition in New York.

In this painting, leaving an area white suggested the intensity of the sunlight.

When depicting the carved surface of the areas in sunlight, I was very careful with the drawing. These lines had to be clearly drawn to show the images carved on the white moonstone.

To achieve contrast, I painted the algae and plants that grew on the side of the steps towards the entrance of the spring. As a result, the shadow areas were clearly defined.

Shadow plan

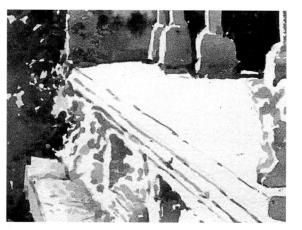

Delineating objects
Notice how the darks are separated by light.

I left some patches of white on the steps which I later filled in with a wash of light yellow-green to suggest the damp algae.

Reinforcing the focal point with light and shadow

Kathmandu morning, 22 x 31" (56 x 79cm)

Mornings in the mountain kingdom of Nepal are usually very busy because people rush to the market to buy or sell their goods.

I used mainly earth colors for the buildings and the ground.

I was careful with the point of focus, which is the building in the center of the painting.

In order to create a special effect I left the façade of the building on the right white to show the light. This indirectly draws the viewer's eye to the focal point in the center.

To reinforce the focal point I painted a Nepali lady walking towards the building in the center.

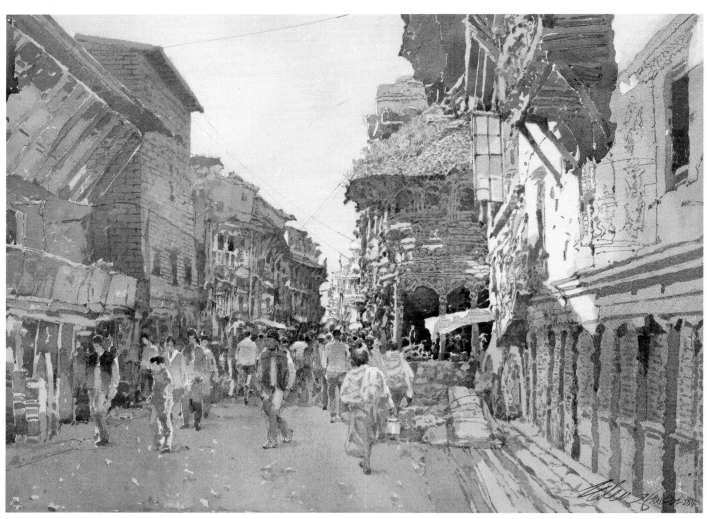

Detail

Applying limited color and contrasts

**Sunlit Hut,
21 x 15" (55 x 38cm)**
I love the sunlight in the morning.
This painting was captured
during a stay in a Malaysian
kampong in the middle of a
rubber plantation. I used simple
color combinations without
complicated secondary colors.
To focus on the main subject,
which is the man resting,
I painted a pale wash of
Cerulean Blue. By using contrasts
of darks and reserved white
paper I introduced the morning
light into the painting.

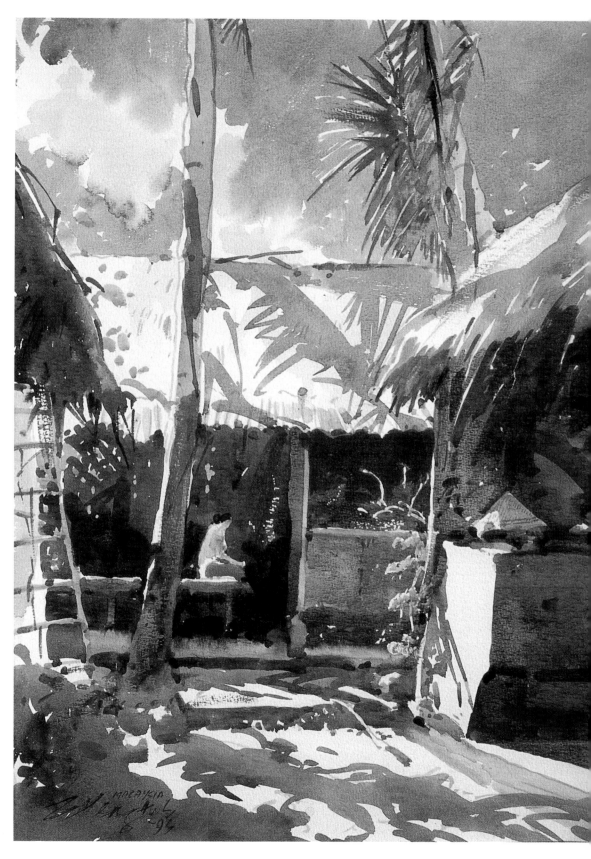

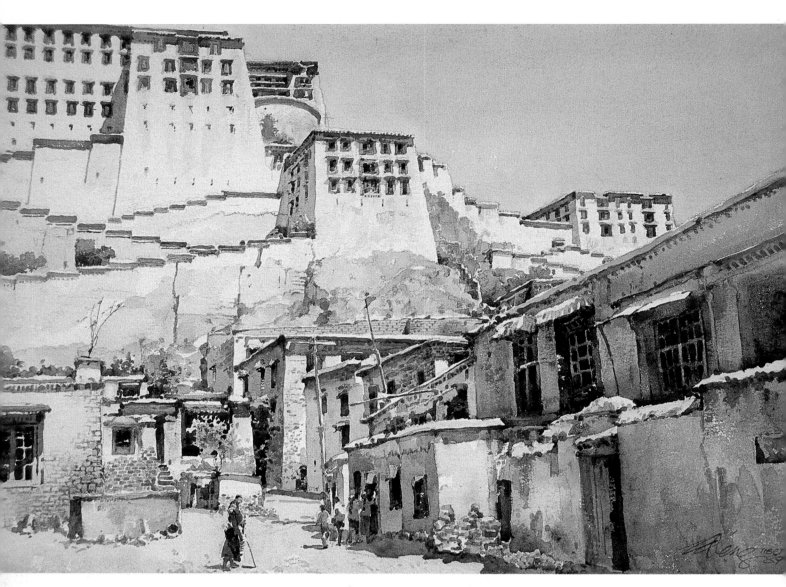

Making the most of the light

Lhasa, Tibet, 22 x 31" (56 x 79cm)

Lhasa, the provincial capital of Tibet, is known as
the Sunshine City. I visited there in the 80s and
was fascinated by the grandeur of the Potala, the
winter palace of the Dalai Lama, which is considered to be an
architectural wonder of the modern world.

I wandered among the houses below the palace and picked a
good spot to paint this mighty monument, The palace façade, being
white, could hardly be differentiated from the pale sky. To make it
stand out, I had to paint a stronger color for the sky using French
Ultramarine mixed with Chrome Orange to give a grayish-blue sky.
I also used stronger colors for the buildings in the foreground.
The main building of the Potala was left white with only a few
dry brushstrokes of Raw Sienna and a mixture of Burnt Sienna
and Cerulean Blue. The light areas stand out more than the
surroundings making the Potala a very distinct focal point.

"To get the luminosity of a
bright sunny day I leave at
least 30 to 40 per cent of the
white paper untouched."

Catching attention with strong light

Comogli, Italy,
22 x 15" (56 x 38cm)

The expression of light is obvious in this painting of a fishing village in the south of Italy. I worked very fast using limited colors. More than 50 per cent of this painting was left white to exaggerate the sunlit areas.

I painted a man walking towards the building as my focal point, and to draw the viewer's eye, I darkened the foreground with shadows. Forceful strokes were used because I wanted to prove that although it is a small painting, the play of strokes and the strong light could catch the viewer's attention, even from a distance.

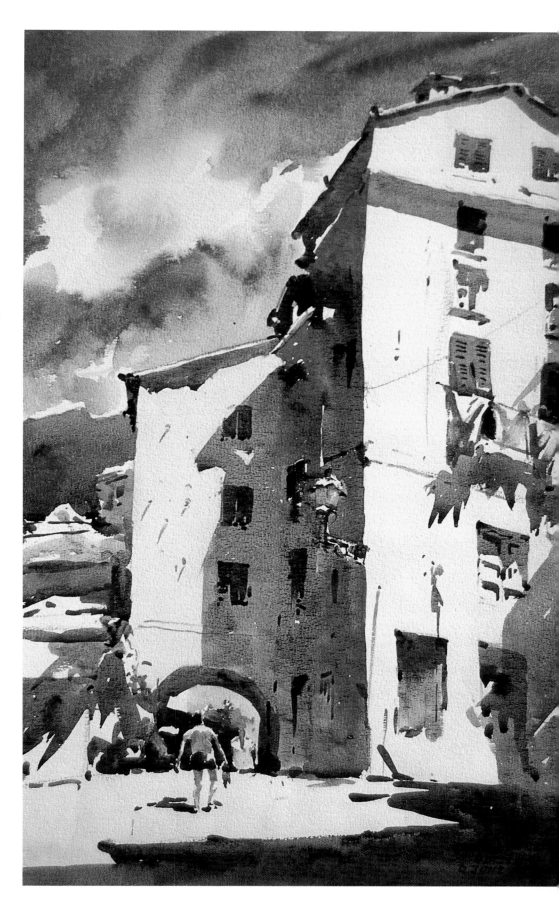

Creating harmony in a sundrenched scene

Varanasi, India,
15 x 22" (38 x 56cm)

The holy River Ganges flows past the city of Varanasi. I woke up at five in the morning to see the sunrise, and watch the pilgrims and locals taking their holy dip in the Ganges. When I arrived at the riverbank, the place was crowded with people near the landing stairs and cremation steps to watch the sunrise over the Ganges River. In a short while the morning sunlight covered almost the entire bathing banks.

I sat near a flight of steps to work. I was able to concentrate on the painting because the crowd had dwindled by this time.

The unique feature about this painting is the row of umbrellas and the people chatting under them. There were bamboo poles with little cages hanging on top. These people and the objects form the focus of the painting. I used a light earth color for the entire painting to show the muddy banks and the earthen buildings.

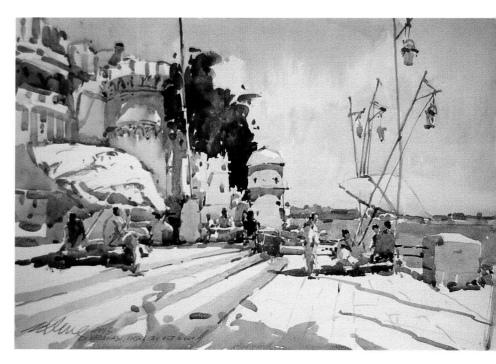

Balancing color, tone and white paper

Mountain Village, Nepal,
22 x 31" (56 x 79cm)

I worked for four hours on this painting in the teeth of a cold mountain wind that came blasting straight from the Himalayas.

I used a mixture of Burnt Sienna and Cadmium Yellow for the light areas of the buildings and a mixture of Prussian Blue and Raw Sienna for the shadows. Fine lines were used to depict the brickwork, which is a feature of the buildings in the Himalayan valley.

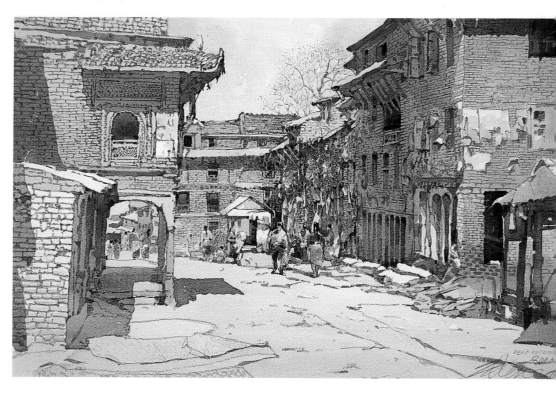

Reserving white paper for emphasis

**Discussion, Nepal,
22 x 31" (56 x 79cm)**

The light in this courtyard, which was shared by a cluster of Nepali houses, is very distinct in the morning. I captured this view from my room in a friend's house. People often gather around the intricately carved bronze pillars which are part of the place of worship shared by the families who live there.

To capture the light I painted the right side with a darker wash of Chrome Orange, Burnt Sienna, Ultramarine Blue and Violet. The people chatting in the center of the painting were my focal point. I emphasized the man standing in front of the two seated women. Notice the light on their clothes. These were left white as highlights of the painting. Many areas in the bronze sculptures and pillars were left white as well. As a result the point of interest is very clear.

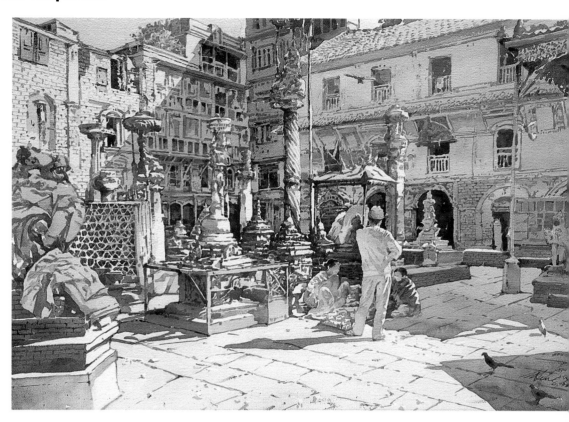

Using tonal divisions for effect

Morning in the Third World, Nepal, 22½ x 30" (57 x 76cm)

I loved the Himalayan mornings during my treks in Nepal, but I also enjoyed the people I met while walking in these remote areas. Even in high altitudes above 13,120 feet (4000 metres) there are people living. Once while I was drinking Sherpa tea at a small motel humorously named "Hotel No Dogs", I saw a girl watching me. It must have been the first time she had seen someone drinking two cups of tea at the same time. I quickly made a sketch of her with my pocket paintbox and took some photographs as reference for this finished painting.

I used the slope of a foothill to direct the eye to the girl. I left the right side of the girl from the shoulder to the thigh white to draw attention to her. The thin line on the side of the hill slope suggests back light.

WORKING WITH
Shadow Shapes

HERE'S SOME MORE INFORMATION ON WHY SHADOWS ARE SO IMPORTANT TO OUR MISSION OF MASTERING LIGHT.

Shadows play a very important part in creating excitement and mystery in a painting. However, because they are intangible, and sometimes not obvious in a scene, inexperienced painters tend to put them in as an afterthought. Even worse, are the painters who are oblivious to their presence! Shadows have to be treated as part of the composition, so their shapes have to be designed. Although shadows look dark because of the absence of light, there is color in them from the reflected light of surrounding objects.

- Shadows are useful because they create a three-dimensional effect.
- They provide stability and solidity to objects.
- When you have made a mistake and figures and objects seem to be floating, shadows can correct this floating effect.

Be precise when painting shadows

Getting the direction of the shadows correct is vital because it shows the hour of the day. The angle of the shadows has to be determined at the stage when the outline of the painting is being sketched. I am as careful as possible in getting the shadows correct, and I do this by observing their formation and direction.

Pinpointing the shadow direction

Dance Studio, Bali, 15 x 22" (38 x 56cm)
While staying in Ubud, the "village of artists", I often visited this studio to watch students learn traditional dancing. Bali is famous for its dances, especially those performed for its Royal Family. If you walk along the Monkey Forest Road in Ubud, you will hear the sound of the gamelan, the Indonesian percussion musical instruments, accompanying the dances. The studio grounds are beautifully serene in the mornings.

Action Plan!

1. Make shadow direction consistent with time of day.
2. Match your shadow color with the overall color scheme of the painting.
3. Make shadow shapes part of the design, not just random additions.
4. Introduce reflected lights into the shadow.
5. Align your shadows with the shape of the object casting the shadow.
6. Introduce cloud shadows.
7. Show perspective in shadows — make foreground shadow darker than background shadows.

Since Bali is very humid and rich in volcanic ash, the soil is extremely fertile and bricks made from the soil very soon become overgrown with algae and moss. I like Balinese arches. When I painted this arch I made sure to include the algae at the base of the arch.

To depict the back light effect I sketched in the outline of the light and shade in order not to lose them later on as the light condition changed.

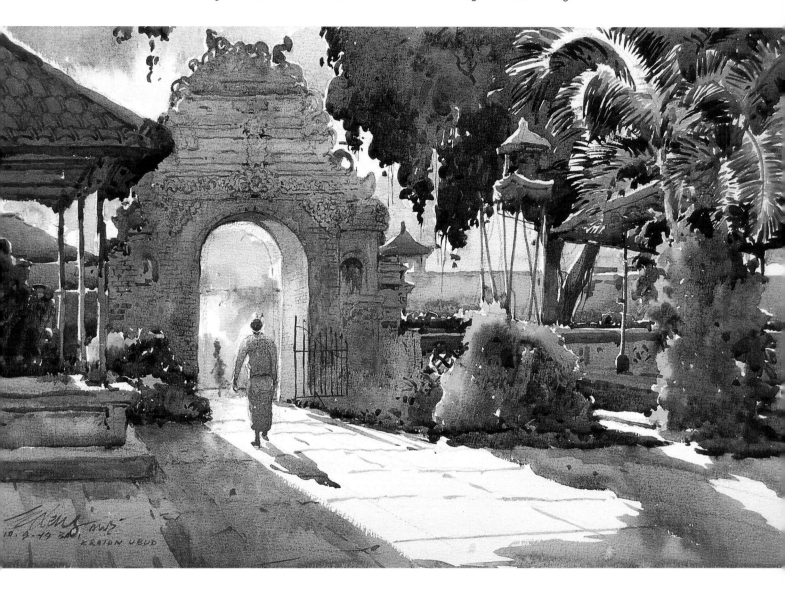

For this painting I began with the arch because it is the focus of the painting. I painted from top to bottom using a mixture of Cadmium Orange and Bright Red merged with Burnt Sienna for the darker areas.

Once all the earth colors were painted I went on to the trees and plants, painting them with a mixture of Winsor (Phthalo) Green, Permanent Sap Green and Lemon Yellow. For the shadows of the plants I used Cobalt Blue mixed with Manganese Blue.

The figure walking out from the arch was painted last.

Shadows can make interesting patterns and shapes, and they certainly liven up a painting.

Thinking about color for shadows

When deciding on a color for the shadows, it is important to take note of the overall color scheme of the painting. If it is a painting dominated by the color green, then the colors applied for the shadows should take on a greenish hue. For example, one of my favorite palnting places, Sentosa Island, is mostly green because of the trees and gardens all over the island. In this case, I would use a mixture of blues and greens for my shadows. I usually make the darkest dark in the shadows a mixture of Ultramarine Blue and Burnt Sienna

Planning shadow shapes

After a color for the shadow has been decided, I will create a design for the shadow. **Shadow shapes should be designed, not put in at random.**

All shadows should be worked out to enhance the main subject.

I prefer to use Ultramarine Blue for mixing colors for shadows because it does not become muddy easily when mixed with another color. It also gives maximum darkness when mixed with Burnt Sienna, resulting in an intense sepia-like color. This color is perfect for shadows, especially when I want very strong contrast.

Balancing light and shade

Late Afternoon, Nepal, 22 x 31" (56 x 79cm)

This was a palace courtyard in the capital city of Kathmandu. It was a sunny day but the fresh mountain air was cool. In this painting I paid particular attention to the woodcarvings on the building. Woodcarving is an ancient artform practiced by the Newars, a tribe that ruled Nepal for a long time.

For this painting I adopted the method of leaving white paper to represent the areas strongly lit by the sun.

For the point of focus I placed the man against a very dark background.

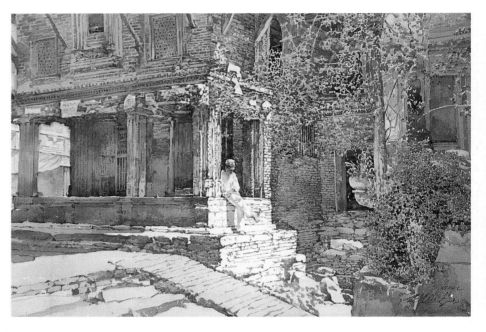

Because the scene consisted mainly of earth colors, I added some vegetation to give balance to the painting and to break the monotony of the predominant earth colors.

Throughout the entire painting process, I used smaller brushes for the intricate lines of the building as well as the plants in the foreground. This painting took longer to complete than others I had done on the spot.

It is important to take note of the shape and direction of the shadow in relation to the subject. For instance, if I am painting a coconut tree at about eleven-thirty in the morning, then the shadow should tell the viewer such information. Although I try to get as close as possible to the shape of the existing shadows, sometimes it is not possible because of the interference of surrounding objects.

Suggesting reflected light in the shadows

Most of the time I study the effects of reflected light in the shadow areas. Stray lights in shadow areas are difficult to render. Streaks of reflected light are often achieved by glazing or fusing colors on to the base color. To do this, I first establish a ground color for the shadows, for instance, a light

(Continued on page 56)

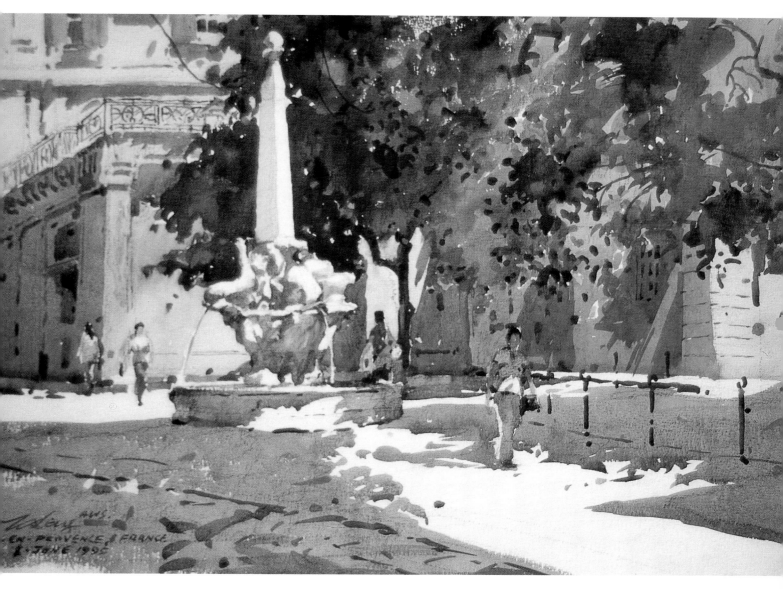

Choosing cooler colors for shadows

Aix-en-Provence, France, 15 x 22" (38 x 56cm)

The summer in Aix-en-Provence is long and I was able to paint until it finally got dark — something quite different from Singapore 6pm sunsets. This street was near my hotel. It was the best time of the year and people everywhere were enjoying the sun.

For this painting I again used my pet color — a mixture of Raw and Burnt Sienna for the light and dark areas. For the light areas, I used a very diluted mixture of Raw Sienna with Vermilion for the light wash as the base. For the trees I used Hookers Green Dark and Cadmium Yellow. For the shadows on the ground I used Alizarin Crimson Permanent and Ultramarine Blue. This is a color close to violet, which I often explore for a cooler shadow.

"Shadows have to be treated as part of the composition, so their shapes have to be designed."

Special texture effect
To get the textural effect on the surface of the tower
and the wall, I used a fine sandpaper to roughen the
first layer of color after it had dried.

Including texture and light

Morning In Bali, 22 x 31" (56 x 79cm)
Collection of the Neka Museum, Ubud, Bali

A typical Balinese countryside scene is incomplete without a Kokul tower
(drum tower), a banyan tree and a split gate. I like Kokul towers because
they symbolize the united and peace-loving spirit of the Balinese people.
A wooden drum is hung in the tower and is beaten to summon the people to
hear an announcement about a festival or any important village matter.
Banyan trees thrive and they offer welcome shade during daily labor.
(A banyan tree is featured on the state crest of the Republic of Indonesia.)

I used a wet-in-wet wash for the trees in the background to suggest the
morning mist. When I painted this scene I paid particular attention to the
stone wall joining the drum tower. Every stone was painted to show
the wall's strength. As for the tower, I sketched out the details of
the carvings and the engravings on the side walls. I left the side
towards the sunlight white paper.

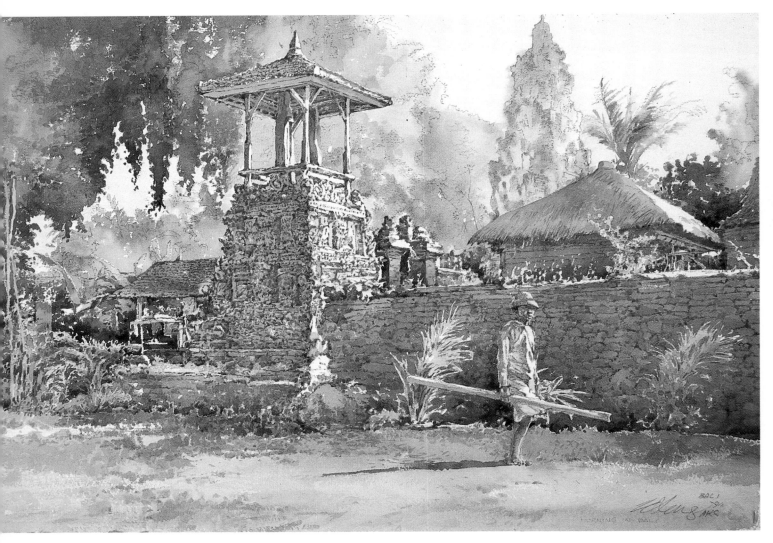

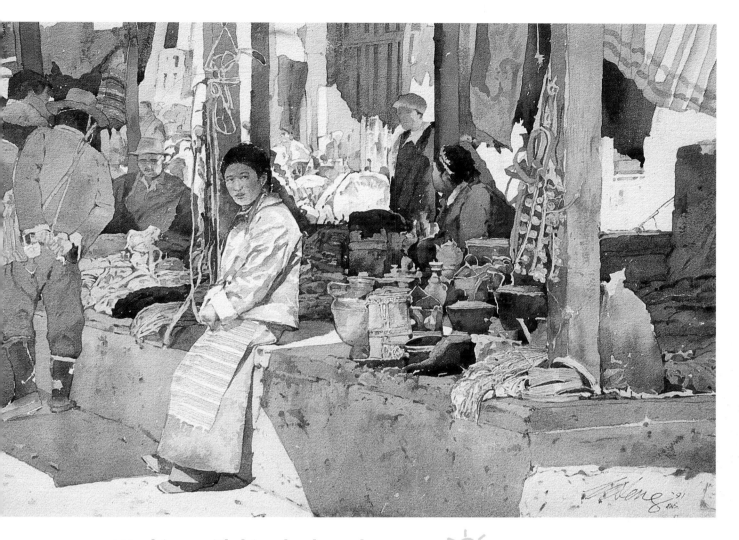

Working with big shadow shapes

Gyantse Market, 22 x 31" (56 x 79cm)

In 1988 I made an overland trip from Kathmandu in Nepal to Lhasa in Tibet. On the way I stopped at Gyantse, a town on the Arniko Highway that links Tibet and Nepal. I made many sketches and took numerous photographs, which I used as references for this painting.

Most other parts of the painting were painted using the earth colors to show the aridity in Tibet.

The point of interest is the woman in the center of the painting. Notice the colors in the shadows behind the sack at right.

By placing this figure against big shadow shapes I was able make her prominent in the composition.

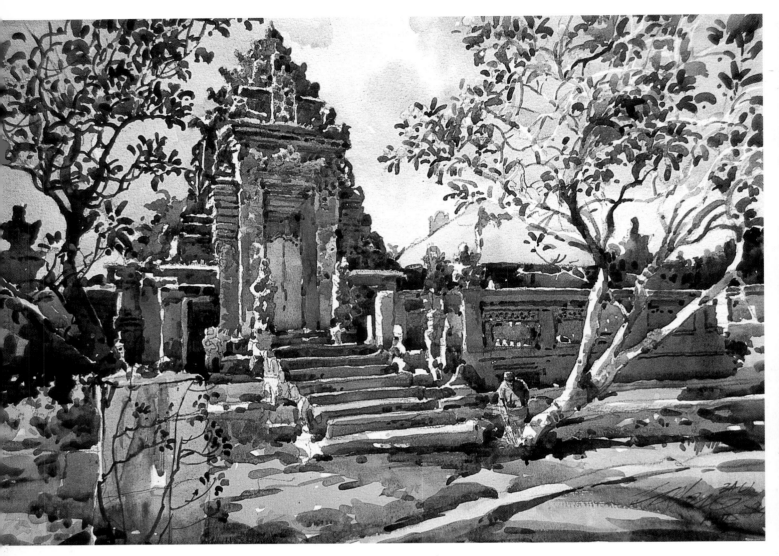

Balancing a light and shade design

Palace Ubud, 22 x 31" (56 x 79cm)

This is a side entrance to the Palace Hotel in Ubud. As in most Asian architecture, there is a familiar wall surrounding the compound. The famous Legong dance, in which young girls perform as nymphs with very skillful hand, body and eye movements, is performed here. Every evening when the gongs beat, people gather near the gate to watch the show.

I painted this scene on a peaceful morning — without the sound of the gongs or the noisy crowd! I loved the colors of the red brick walls of the entrance. This type of door can be seen everywhere on the island of Bali.

Again for this painting I used the white of the paper to show the light areas. The contrast of light and shadows is more noticeable in this painting because I used stronger, darker colors for the shadow areas. The frangipani tree on the right was deliberately painted dark to suggest perspective.

Creating action and mood

Old Corner, Nepal, 22 x 31" (56 x 79cm)

To successfully create a three-dimensional effect in a painting, shadows must be clearly defined. Here, the focus of the painting was the woman walking through the narrow lane. She added life and interest.

As usual I confined my colors to earthy siennas, Orange, Indian Red, Hookers Green and Ultramarine Blue.

I balanced the painting by bringing together the darkest and the brightest parts. I was more careful with details in this painting because the weathered façade of the ancient building presented very interesting relief and woodwork.

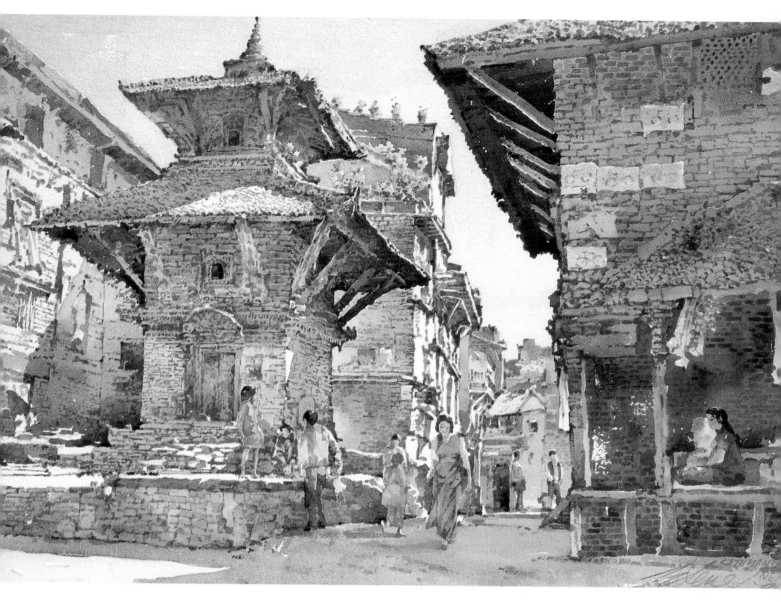

The movement of the clothes adds interest and life.

Reflected light

Shadow color

"As you can see, some of my paintings are done with great detail and control, while others are quite loose and free."

Glazing to develop shadows

Boon Tat Street Singapore, 22 x 31" (56 x 79cm)

This is one of the streets in Singapore where the early settlers from Southern China lived. Most of them worked as laborers or seamen because Singapore was not developed and jobs were few. In Singapore today there are many streets named after the different Chinese dialect groups who migrated here. This painting shows the junction of Boon Tat and Amoy Street. (Amoy is a city in the Fujian Province of Southern China). Like many other old buildings in Singapore, these were scheduled to be demolished to make way for new developments. As I keep saying, I have strong feelings for these old buildings and have painted them many times.

I used a glazing method for this painting, leaving a lot of whites to emphasize the strong sunlight. To bring out the shadows I used a dirty earth color consisting of Burnt Umber, Burnt Sienna and Hookers Green.

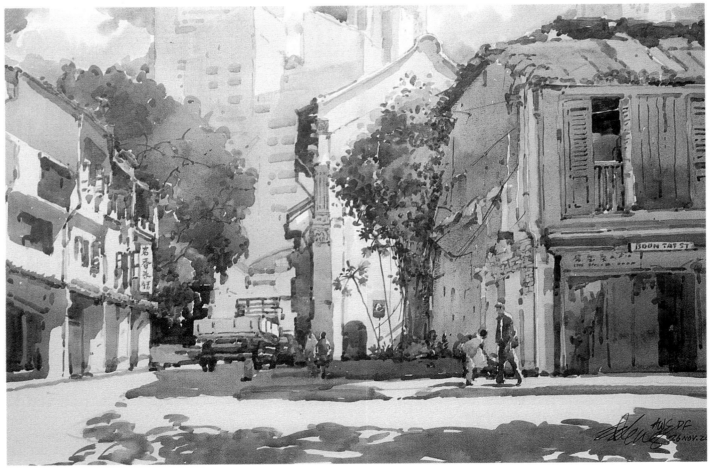

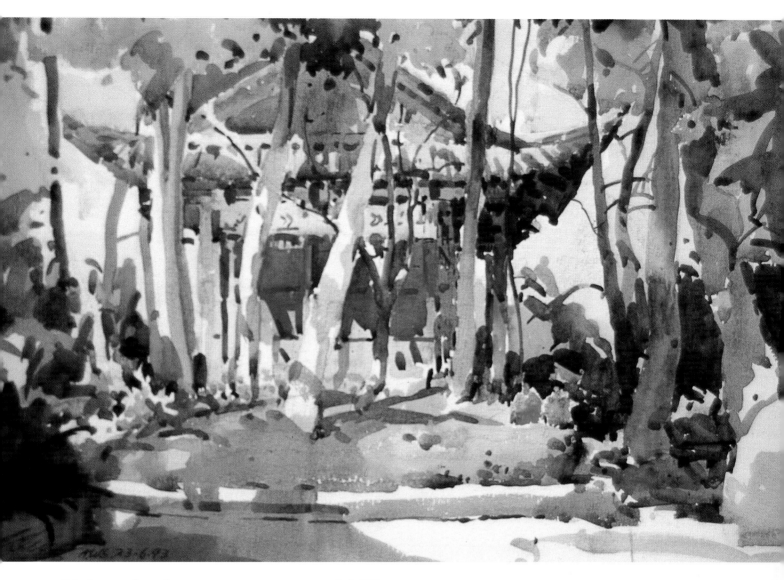

Using shadow patterns to add life

Kunming Garden, China, 15 x 22" (38 x 56cm)

The art of designing gardens in China dates back to ancient times. While taking a quiet afternoon walk in a beautiful garden in Kunming in Yunnan Province I was attracted to this pavilion. Among a canopy of greens I found this vermilion door beneath the elaborate tiles of a Ming roof.

I sketched the outline with a 4B pencil, placing the trees as they were, but I eliminated many unnecessary branches that crossed the focal point. When painting this scene, I incorporated the light and the shadows as part of the composition. Sometimes, when a scene is unremarkable, an interesting composition can be created using the light and shade in the area.

Achieving mood with shadow shape and color

**Resort, Bali,
22 x 30" (55 x 76cm)**

I left a number of white spaces in this painting to accentuate the woman walking down the steps to the courtyard. This scene in a tropical paradise may look simple but the shadows play an important part.

I used a continuous clear blue for the sky to clearly show the contrast between the sky and the sunlit roof. Most of the time I kept to a basic palette of Raw Sienna, Burnt Sienna, Chrome Orange and Cobalt Blue. Because the focus was on the woman, this is where I painted the brightest colors of orange and red.

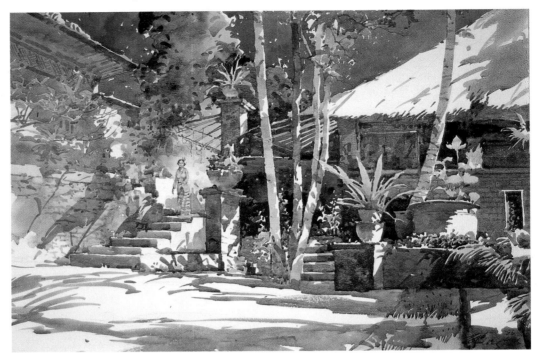

Making a point with contrast

**Food stall, Ubud,
22 x 31" (56 x 79cm)**

Traveling round Bali to tourist spots or places of worship is easy, and there are always interesting shops and stalls along the way. I like eating in the *warungs* or Indonesian stalls, and while sitting there one day I watched different shoppers buying provisions and household goods. I also liked the plants growing around the stall. Dogs are a common sight because they are kept as pets and guards. However, they are also scavengers and become a problem when too many of them stray on the village roads. I painted the dog in the light and the lady in the shadow. This strong contrast became the focal point of the painting.

Thinking about light and shade before color

**Sophia Apartments, Singapore,
22 x 15" (55 x 38cm)**

This pre-World War II apartment along
Sophia Road in Singapore once attracted
many artists and students because it is near
an art academy. It has been renovated, like
many other old buildings in Singapore, and
consequently has lost its original ambience
and charm.

As you can see, some of my paintings
are done with great detail and control while
others are quite loose and free. Sometimes,
on the spur of the moment, an exciting area
compels me to paint it and that's where
I begin my sketch for a watercolor. I often
venture into areas that are least frequented
by artists so that my paintings are different
and have a unique approach.

I considered the placement of light and
shade before I added the colors. The outline
of the shadows were sketched in with a
pencil. The point of interest was the narrow
corridor leading to the two figures in the
background.

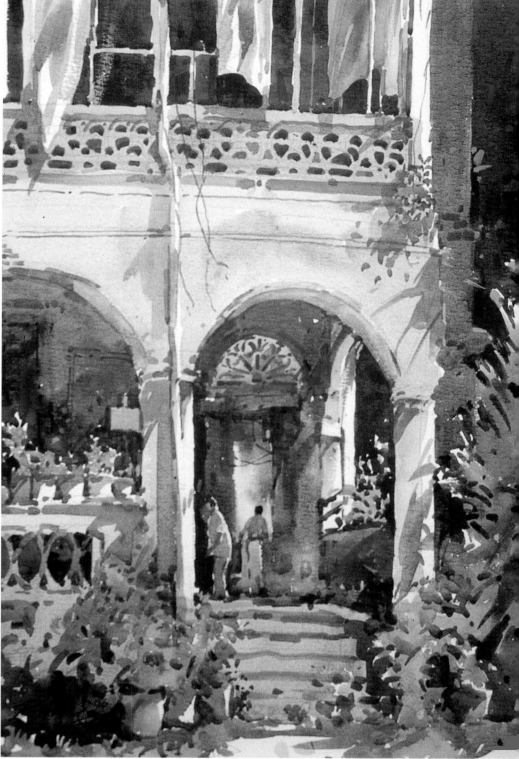

Shadows have to be treated as part of the composition

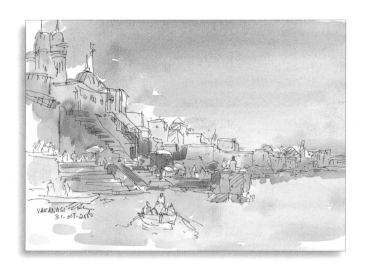

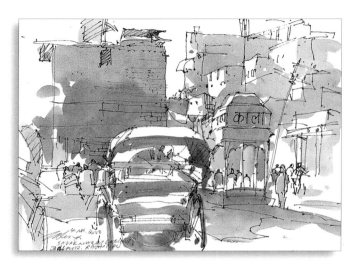

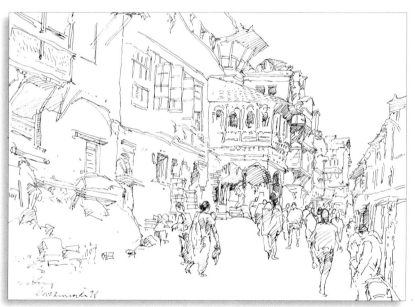

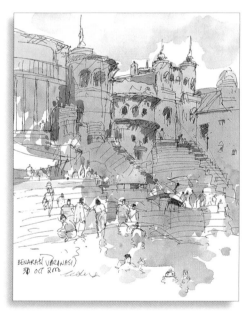

(Continued from page 46

mixture of Ultramarine Blue and Burnt Sienna to get a pale gray. When this color is completely dry, I add glazes of the mixture of Ultramarine Blue and Burnt Sienna for areas unaffected by the reflected light. Where the reflected light is softer, I fuse two different densities of this mixture for the gradual change in the shadow area.

Shadows caused by clouds in a scene can be very dramatic and can give life to a painting. A painting that is quite flat in color can be turned into one that is lively by adding shadows from the clouds. If a foreground is bare, and it is too late or unreasonable to add in any

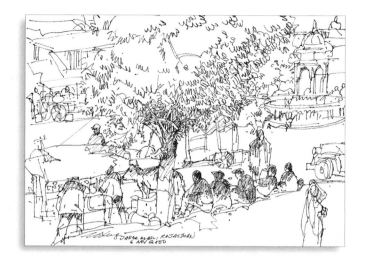

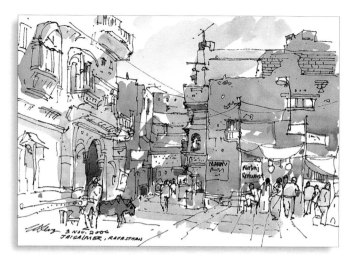

meaningful objects, I sometimes add cloud shadows for balance. Many English watercolor masters used shadows to depict the vastness of meadows and pastures.

Using perspective in shadows

Showing depth in shadows is equally important. When the shadows are slanting, or if I am backlighting distant buildings or people, the color of the shadows nearer to the subject is usually heavier than those further away.

Finally, to be convincing, shadows, must be transparent! □

DIFFERENT Approaches MAKE PAINTINGS Different

TO CREATE A DYNAMIC PAINTING THAT STANDS ON ITS OWN TWO FEET YOU MUST USE DIFFERENT APPROACHES TO CONVEY MORE ACCURATELY WHAT YOU WANT TO SAY. THAT MEANS DIVIDING THE COMPOSITION AND ANALYZING EACH PART ACCORDING TO DIMENSION, ACTION, TONAL VALUE, SIZE AND PLACEMENT OF SHAPES.

Many years ago I remember showing a friend a painting I'd done of a street scene in Kathmandu, Nepal. He asked, "Which part of Chinatown is this?" I was very surprised that my painting of Nepal was mistaken for a Chinatown scene. After thinking about it I realized this problem arose from my many years of painting familiar local subjects and the public's prolonged exposure to those paintings. In fact, I had begun to be identified with subjects painted in a particular style in "my colors". People identified me with the Singapore River and Chinatown scenes. I think

that even if I had painted a river scene in France they may have mistaken it for the Singapore River! I know I had to break away from this label or else I would be forever stuck with it.

The root of the problem lay in the fact that I had been over familiar with my subjects. I had painted almost every nook and cranny in Chinatown, and every scenic spot along the Singapore River. Undoubtedly, painting these scenes was effortless for me — I knew the different compositions and the colors to use. But was this an ideal situation for an artist? Definitely not!

To avoid my usual practice, I looked for unfamiliar areas that would enable me to use more interesting

Action Plan!

1. Divide the composition into various parts.

2. Analyze each part according to the dimension, action, tonal value, size and placement of shapes.

3. Decide on treatment, wet-in-wet, wet-on-dry, dry brush, combination and calligraphic brushwork.

Changing my method of application

Hydra, Greece, 22 x 32" (56 x 79cm)

The Greek resort island of Hydra was an interesting subject to paint. As I approached the island from the sea I was very excited to see the houses perched on the mountain slopes. From afar it looked like a Lilliputian colony and the sight prompted me to make many sketches.

Normally I would apply a light colored wash for the whole area first and then add other colors on each house. I wanted to capture the houses accurately, so instead I painted them individually. In this way I was able to concentrate on

one house at a time and I also had the opportunity to study the features and style of each house to achieve a more interesting presentation. After painting the houses I painted the boats and then the sea, using darker, bolder strokes to show the movement of water.

One point I wanted to make was the separation of the rock wall from the walls of the buildings. The rocks had to be clearly defined. The mountain was painted last with a light wash to suggest distance. Before the wash dried I added the trees using the wet-in-wet method.

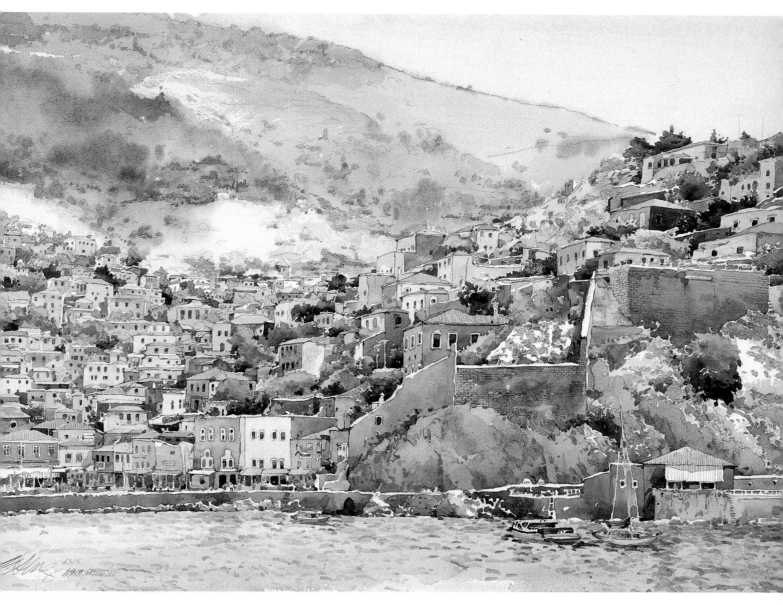

Detail

Detail

compositions painted with different approaches and color schemes.

In Singapore it is the light and the activities of the people that are most noticeable. Singapore has undergone tremendous changes since the time of British rule. What is unique about the streets in Singapore is the contrast between the old and the new buildings, ultramodern skyscrapers contrast with old colonial shop houses. Besides looking for "new" subjects, I discovered that in order to create an outstanding painting which will interest and impress viewers, I had to pay attention to the techniques I used.

The glazing approach

When I want to paint a scene with plenty of details and definite structures or forms, I use the glazing approach. Glazing is useful when painting rugged areas like old clapboard houses, rock formations, trees in the foreground, the reflections of water, and focal areas. This approach can be found in my paintings of Nepal and Bali, as well as in my paintings of houses in Chinatown, Singapore and street scenes.

How glazing works

Layer upon layer of color is applied until I am satisfied that the desired color or effect is achieved. The first layer is usually very light and transparent in order to achieve a high degree of transparency.

The second layer may be more intense than the first. The final layer may almost be opaque. The important point to remember is that each layer must be totally dry before I glaze over the top of it.

Over time I have built up a certain unique character to my strokes when I apply the layers. The distinctive shape of the glazes has developed into a design of my own. When I use this approach, the

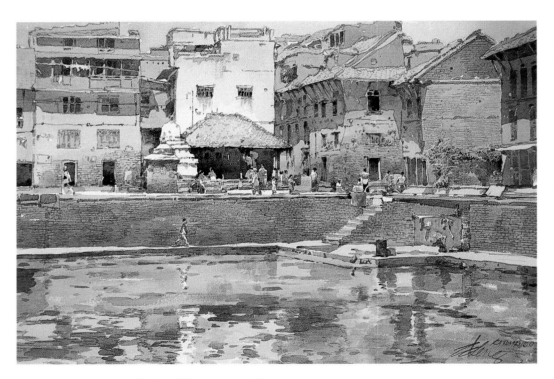

Contrasting solid stillness with watery movement

Ancient City, Nepal, 22 x 32" (56 x 81cm)

For generations, the Shah kings and Rana princes ruled Nepal and built beautiful palaces. Bhaktapur lies towards the north-west of Kathmandu and was one of the three kingdoms of Nepal.

I had tried to paint this scene many times but each time I painted something else instead. I think the reason was that the pond gave me a sense of insecurity because it occupied almost one-third of the scene. I decided the only way to portray it was to capture the movement of the water and reflections.

Finally, I made this painting and placed the emphasis on the pond and the road that leads into the center of the painting.

There is contrast of stillness and movement. The buildings occupying two-thirds of the painting represent the still part (except for the few people), whereas the water, due to the wind, was moving all the time.

The few people in bright colored clothing became the neutral shapes between the buildings and the water.

strength of the painting is noticeable, even from a distance.

When I am not satisfied with a painting, especially when it is not lively enough, or the colors are not strong enough to impress viewers, I do a final touch-up using strong glazes. I patch up areas that are not sufficiently dark to emphasize the bright areas, and I add glazes for weaker or uneven colors to freshen up and even them out.

The wet-in-wet approach

I use this approach especially for scenes in temperate countries to give an atmospheric effect to my painting. For example, when painting a misty morning or a light rainy day in a remote village, I first wet the surface of the paper with a sponge, or sometimes I use a water sprayer — the type used for spraying clothes before ironing them.

I premix the colors before I apply them on the paper. Then I layer the washes just as I do for the glazing approach, except that these are applied on a wet surface. Care must be taken with this approach, especially when painting on a sunny day because the colors dry faster than you can control. However, if

Leading the eye to the focal point

Thimi Yard, Nepal, 22 x 31" (56 x 79cm)

This picture was created with the intention that the viewer's eyes would skim over the surroundings but focus immediately on the pillar near the center of the painting. Eventually, you will be able to lead the viewer's eyes to the place you want them to concentrate on. Most of the time I set focal points, but I don't make them all eye-catching because then there are too many interesting spots in the painting.

I have painted this place on many occasions This is the first time I made the pillar the focal point instead of making the pagodas, temples and stalls the center of attention.

I guided the eye using the zig-zag path of white. I put most of the color in the area near the pillar, which was the star because it was dark against light.

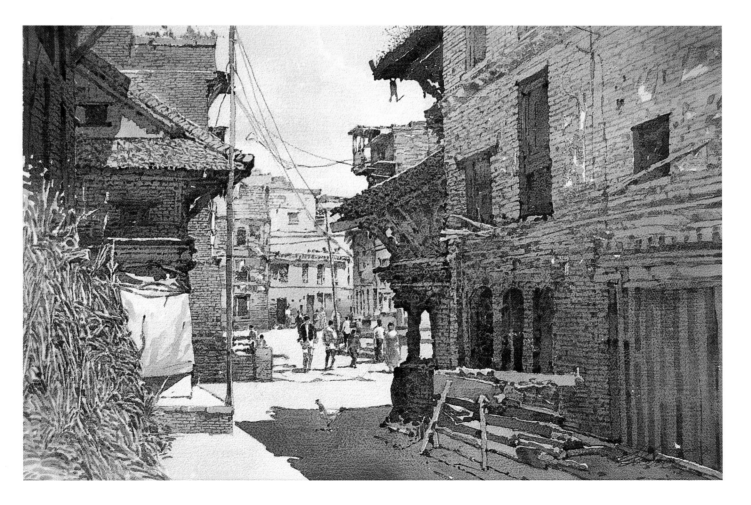

Glazing steals the scene

Raffles Hotel, Singapore, 22 x 31" (56 x 79cm)

The Raffles Hotel is a very old and well-known hotel in Singapore. Rudyard Kipling, Somerset Maugham, movie stars and many other celebrities have stayed there. The hotel has been renovated and extended, and a new entrance shifted to the left of the building. I have depicted the old familiar entrance of the hotel.

I used a contrast of white and green because the morning sunlight was strong and distinct and the vegetation lush. The palm and coconut trees at the side of the hotel were clearly drawn to depict the tropics. In this case, I carefully adhered to the lines of the hotel architecture because it is a classic example of an old British colonial-style building.

The main technique in this scene was glazing. I worked from right to left, starting with the palm trees then going on to the building.

Manipulating color for focus

Street, Hong Kong, 22 x 31" (56 x 79cm)

Hong Kong is famous for its numerous signboards. This is a scene during the rush hour in the morning. There are some old buildings in between ultra-modern ones and as a result of this combination, the sunlight displayed various intensities in light and shade.

The interplay of light on the building on the left side of the painting is very interesting. I used a wet-in-wet approach, making a soft fusion of Orange, Cadmium Red, Indian Yellow and Lemon Yellow, and leaving the center gap white to show the highlight. The bottom one-third of the painting was done in darker tones to direct focus to the sunlit tops of the buildings.

Combining soft and hard techniques

Taman Ayun, Bali,
22 x 31" (56 x 79cm)

As I said previously, my preferred Balinese subjects are still the drum tower and the splendid courtyards that surround a place of worship. The entrance to such places is usually dominated by a giant banyan tree, which not only provides shade but is often believed to be the dwelling place of spirits. Banyan trees are objects of worship during daily prayers and on festive days.

In this painting I adopted both the soft and hard techniques of watercolor painting.

I used wet-in-wet for the banyan tree to give a soft finish, and then I used my glazing technique to produce definite lines and strokes for the drum tower and other structures. In this way two different approaches were featured in the same painting.

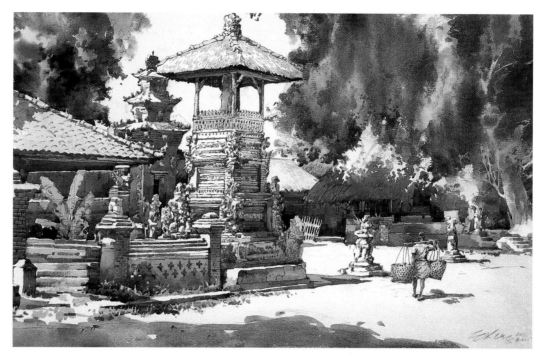

Hard treatment

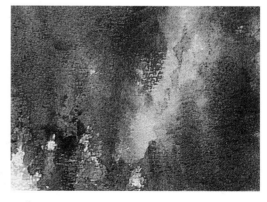

Soft treatment

the colors have dried too quickly, a water sprayer can come in handy for moistening the area you wish to add color to without creating any hard edges. The wet-in-wet effect can still be retained even when you add more glazes.

Combined wet-in-wet, glazing and dry brush approaches

Nowadays my paintings of places such as Bali, Nepal or the Himalayan mountains are easily recognizable by my viewers because I choose scenes unique to those places such as temples, festivals or the people. Besides this identification of place, I often apply a combination of the wet-in-wet and the layered glazing methods for my paintings. This combination of techniques provides more versatility and gives me the freedom to interpret my thoughts better.

I usually begin by painting wet-in-wet for the background scenery and then I apply the layered glazes for the middle and foreground to focus on details.

I use dry brush techniques for fine lines in wooden structures, the branches of trees and cracks in doors and on the ground.

Dry brush treatment

**The Return, Bali,
22 x 31" (56 x 79cm)**
Most parts of Bali are still rural and are often only accessible by bicycle or on foot. Here, I depicted a farmer returning from town after a day of shopping, being greeted by his neighbor and son.

I used a dry brush technique for the plants and left white those areas lit up by the morning sun. To depict the rural environment in this remote village, I used earthen colors for the main color scheme of the painting. I made use of the light and dark contrast centering around the two figures on the right of the painting to highlight the focal point.

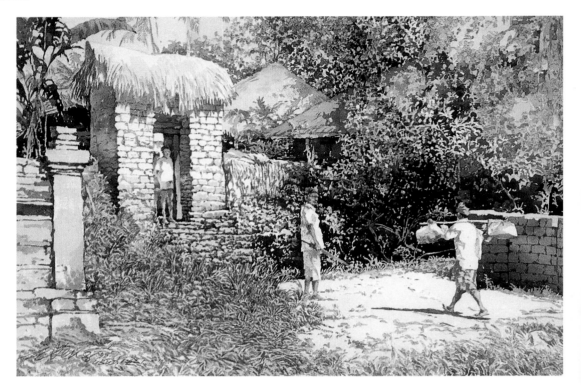

Using only a few transparent washes

**Xiangxi China,
22 x 31" (56 x 79cm)**
Xiangxi is a part of Hunan Province in China. It is a rural area where most of the people are peasants. The area is landlocked but the scenery is enchanting. I heard about this charming place from artist friends living in China.

I used the whites of the paper to attract the eye to the focal point. The play of light during the early hours of the day was exciting and to bring out the liveliness of the area I did not want too many layers on the base colors of Raw Sienna, Burnt Sienna and Indian Yellow. To achieve transparency I very carefully observed the colors and textures of the buildings before I laid a wash.

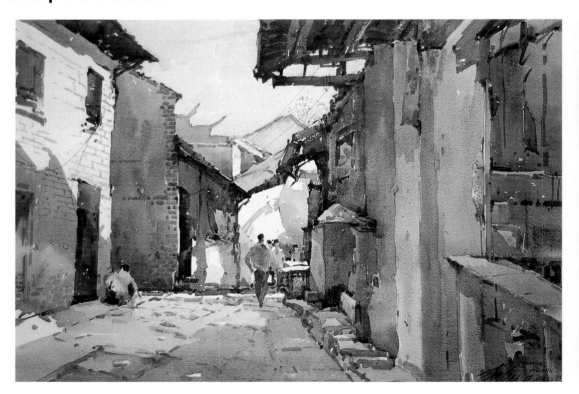

Oriental brushstrokes

Through my years of looking at Chinese and Japanese ink paintings, I have devised a system where the Oriental stroke can be put to good use for traditional watercolor painting.

In some of my paintings I add a graceful frontal branch with some leaves. Here I painted some fall leaves in red and orange. These strokes can be combined with Oriental brushstrokes and are useful for balancing a painting, or to fill up space that looks bare. □

Using mostly wet-in-wet and some dry brush

Brugge, Belgium, 15 x 22" (38 x 56cm)

I rarely use the wet-in-wet method entirely as a technique for my paintings. Most of the time I use a combination of the wet-in-wet and the glazing technique. In this painting, 80 per cent of it was done wet-in-wet with the other 20 per cent dry brush to show the bank of the river.

The outlines of the scene were drawn very lightly just as a guide to the areas to be painted. Most of the other details were added during painting to achieve a spontaneous effect. To do this I mixed the colors I wanted to use on the palette beforehand so that I could work fast and spend less time on mixing as I moved along.

For the fall colors of the trees I used Bright Red, Raw Sienna, Burnt Sienna, Burnt Umber and Cadmium Yellow. I mixed a cool Mauve with Prussian Blue for the distant cathedral. Using a very light mixture of the Mauve and Prussian Blue, I painted the water with the reflections of the fall colors.

Finding my own way of painting snow and ice

Mount Everest, 22 x 32" (56 x 81cm)

Going to Tibet to paint had been my dream for many years and I was naturally delighted when I had the rare opportunity to embark on a trip to Tibet from Chengdu, China, in 1986.

I traveled by bus from Lhasa to Zhangmu, my destination, near the border of Nepal. During the trip I stayed in several towns and villages. The thumbnail sketch of this painting was done in New Tingiri near the Everest Base Camp. The morning was freezing cold and I sketched wearing gloves, which was not an easy thing to do. I was surrounded by yaks which were forraging for any hay or dry grass, and I had a group of People's Liberation Army

officers watching me while I struggled to paint this breathtaking scene. They must have thought that I was mad or too poor to afford a camera. I told them that I was trying to make my own history, that is, to paint in sub-zero conditions. It was the challenge I had set myself before traveling to Tibet and the Himalayan region.

Most parts of this painting were done using the wet-in-wet technique. I first left the peak and the areas lit by the sun white. I didn't use masking fluid. Being from the tropics I was not used to snow and ice, much less painting it, so in my excited state I tried different ways and means to capture their characteristics.

After selecting the colors for the mountain, mostly Prussian Blue, Cobalt Blue and Ultramarine Blue, I put a little of each on my palette. I painted as fast as I could on the wet paper, each time fusing the blues and mixing dark areas with a little Burnt or Raw Sienna. I waited for these base colors to dry before I painted in the lines of the cracks shaping the mountain and the glacier. This was the crucial part of the painting since Everest must look like Everest — after all images of this mountain have appeared in many publications and journals.

FINISHING OFF FOR **Impact**

THERE COMES A TIME IN A PAINTING'S LIFE WHEN YOU HAVE TO STOP AND EVALUATE IT TO SEE IF YOU ARE ON THE RIGHT TRACK.

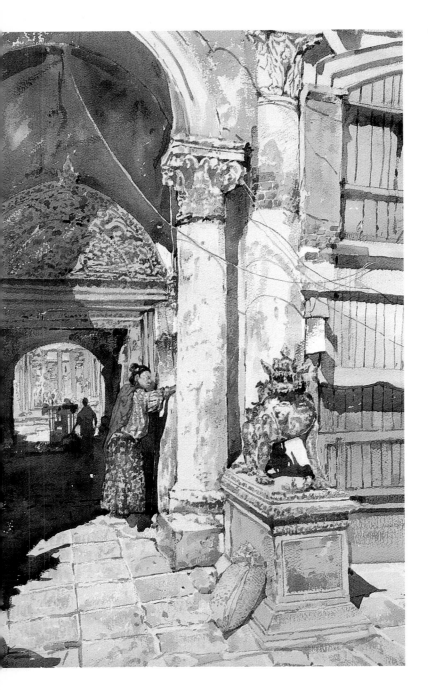

Whenever I am about to complete a painting I check the following crucial elements: harmony of tonal values, unity of color, and overall balance in the composition. Checking the color harmony is as important as checking whether the values are appropriately placed and balanced.

Checking color

It is color that makes an impact — it comes before anything else. Paintings by the Impressionists are totally captivating. If you study an Impressionist painting closely and then close your eyes, you will "see" a vividly colored after-image.

Place your figures early on

Entrance to the square, 32 x 22" (81 x 56cm)

This is a vertical painting of Nepal done during my last trip to that country. I used the pillar as a pointer to the focal point, which is the woman. I concentrated on the shadows on the left and balanced this on the right with the bronze lion, the guardian of the shrine.

To show depth and distance I painted a silhouette of a figure walking at the far end of the passage. This clearly defined the size of the building. It is not always easy to define the size of a building, monument or a boat unless a figure is painted in for comparison. In some paintings however, the figure may not be necessary because it may spoil the work rather than enhance it. It is wise to determine whether you need a figure before you start painting and, if so, decide where you will put the figure then rather than place it as an afterthought. I have seen many paintings at exhibitions which would have been more successful without the figures.

I believe the most attractive element for a viewer is the color — not the subject, the composition or even the size, even though each of these play a part in the success of a painting. To me, it is still color that stands out among the rest.

The colors should be consistent with the overall painting and should harmonize with the planned base color. Colors that are not in line with the main color scheme should be eliminated. For example, if the theme is earth colors, then whatever you paint should adhere to the main color scheme. Sometimes, when I find that a color does not match, I add a glaze of earth color to provide consistency to the overall color scheme.

Checking tonal value

Tonal values are the life-blood of a painting, especially in watercolor. A painting with too much mid-tone becomes flat, one with too much light color looks anaemic, and one with too much dark value loses its luminosity. Judging a painting for balance in values is like getting the correct amount of seasoning in a gourmet meal. If there is insufficient seasoning, the dish becomes too bland and if there is too much seasoning the dish becomes unpleasant, or even unpalatable.

A check on the main point of focus is necessary to find out whether the tonal values are in place. This can be done by scrutinizing the focal point and asking yourself whether the contrast and color balance are right.

Artists should be very careful when using mixtures of Burnt Umber, Vandyke Brown, Sepia and other dark colors. I often mix a dark color using Ultramarine Blue and Burnt Sienna which gives me a dark gray. By adding water or varying amounts of the pigments I get a variety of tonal values. I find it safer to mix a dark color then to use a ready mixed one because I find the pre-mixed dark may not be compatible with my base color, which can result in muddiness. If this happens correction can be almost impossible.

Here's the painting on the opposite side but without the figures. Figures really do make a difference to a scene!

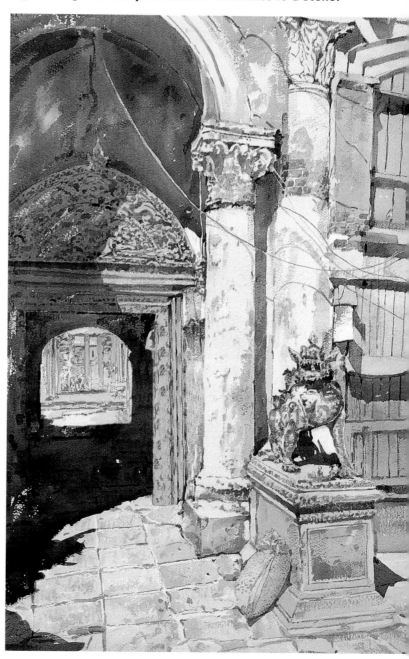

Playing down what you don't want to emphasize

Clarke Quay, Singapore, 22 x 32" (56 x 81cm)

Clarke Quay, on the bank of the Singapore River, was once the thriving heart of commerce and boasts an environment made up of the old and the new. I have difficulty whenever I have to paint high-rise buildings in Singapore because their simple, ultra-modern outlines usually do not match the more characterful surroundings. This can result in an unbalanced painting. It is not only the composition that can spoil the design, but more often the features of these buildings. The difficulty is that I can't leave them out because they are a vital part of the scene — they are simply too big to be ignored.

For the high-rise buildings I used a pale color and painted the more interesting buildings in more detail with a darker color. I checked for balance and added reflections on the water after painting the boat passing under the bridge.

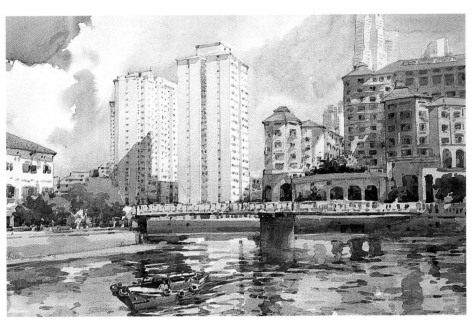

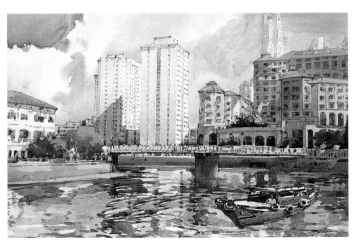

Placement is everything — compare these altered versions with the real thing and you'll see it's true!

FOCAL POINT ✔
TONE ✔
COLOR ✔
BALANCE ✔

> "Tonal values are the life-blood of a painting, especially in watercolor."

Balance

Finishing off a painting in the studio after a hard day on site is a must. This requires a sharp eye and plenty of imagination because it's easy to get lost on site when the clouds and sunlight are always changing. Sometimes I find a certain area in a painting has been overworked and other areas have been neglected. A great amount of work is still not done at the end of the day. Getting the right colors back and keeping the painting in harmony can then prove difficult. What I do is to sit back and study the painting again. I let the focal point stay as it is and mix a color nearest to the main color of the focal point and start painting the supporting elements. In this way the fixing process can be achieved. Rushing to rectify a situation can sometimes result in blunders and the loss of a painting. The ideal approach is to stay calm and tackle each part with great patience.

The first person to admire your painting is yourself — and that makes you an art critic. I don't wait for others to tell me where I have gone wrong. I would rather find any mistakes myself. Be as critical as possible with your own work and do not let flattery make you complacent. It is best to bear in mind that watercolor painting is a continuing process and constant practice is absolutely necessary for better results. □

Making a distinct focal point

Emerald Hill, Singapore, 15 x 22" (38 x 56cm)

The focus of this painting is the entrance to one of the four terrace houses.

The use of dark blue, a mixture of Prussian Blue and Winsor Green, for the windows above the archway and the inner doorway catches the attention of the viewer.

The light yellow-green of the trees and plants pointing towards the arch entrance support the focal point. The different tones and shades of green also lend support to the focal point.

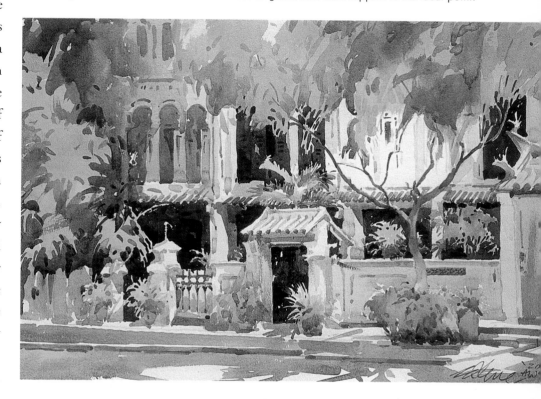

FOCAL POINT ✔
TONE ✔
COLOR ✔
BALANCE ✔

You will notice that the focal point is approximately in the center of the painting, making it easily recognizable by the viewer. When evaluating a painting, it is important to check that the composition is sound and the area of interest distinct.

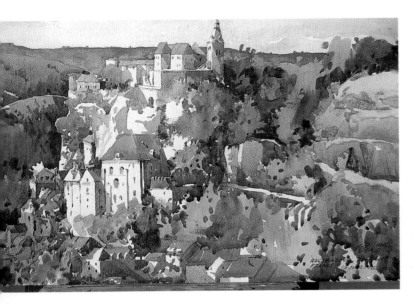

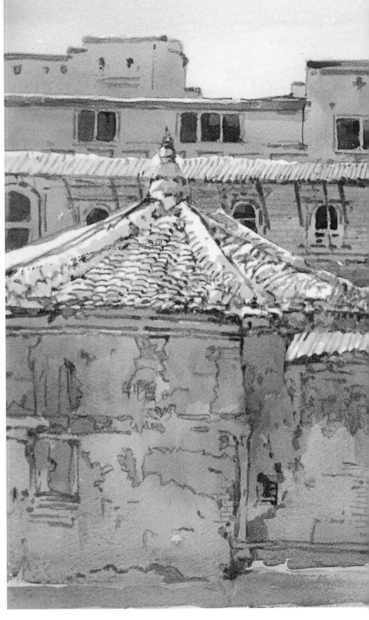

Dealing with lots of green

Rocamadour, France, 15 x 22" (38 x 55cm)

This painting was done from a vantage point opposite the famous chapel. The scene was majestic. I left the buildings white and colored the surroundings so that the focal area was clearly and distinctly obvious. I worked very fast without elaborating on the details, painting the scene as it was.

The rock surrounding the chapel was painted with Cobalt Violet mixed with Cobalt Blue. The distant mountains and forest were colored with a dark tone of Hooker's Green Dark and Indian Yellow. When the painting was nearly completed I evaluated it and added a darker shade on the center left and top right corner to ensure that the painting was well balanced.

FOCAL POINT ✔
TONE ✔
COLOR ✔
BALANCE ✔

"A painting with too much mid-tone becomes flat, one with too much light color looks anaemic, and one with too much dark value loses its luminosity."

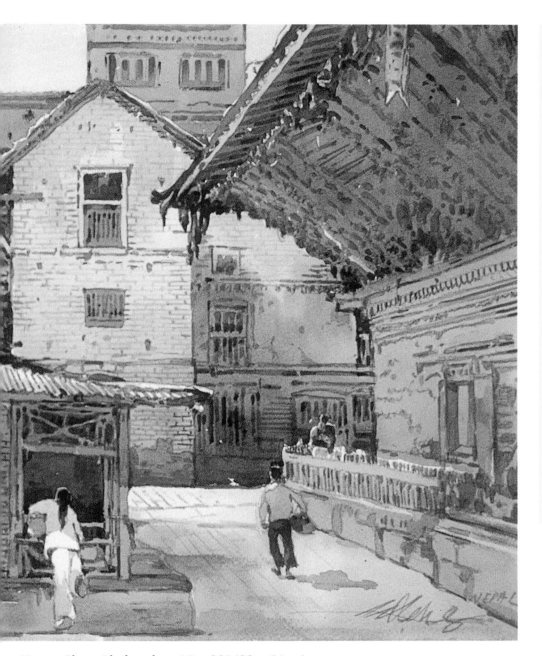

How to liven up a painting

The dry brush technique can be used to liven up parts of the painting, especially areas that are flat or bare. For example, I might paint a row of bricks and find that they do not stand out. What I do is apply dry brush strokes for the cracks and holes in the bricks. "Accidents" in the form of strokes, washes or glazes may be used to advantage and should be retained. Some strokes are hard to come by and cannot be deliberately created to suit a certain composition. Not all accidents are happy ones, however. Some can ruin a painting.

Yogurt Shop, Bhaktaphur, 15 x 22" (38 x 56cm)

I woke up early one morning and rode a bike to this little village in Bhaktaphur. It was a perfect fall day, with the golden light of the morning sun adding a rich crimson yellow to the scene.

I chose a corner of the shop with the little girl buying yogurt as the point of focus. Most of the colors used in this painting were a mixture of Raw Sienna, Cadmium Yellow, Burnt Sienna, Mauve, Ultramarine Blue and Alizarin Crimson Permanent.

I left the clothing of the girl white and added a light Cobalt Blue for the shades. Particular attention was paid to the intricate carvings and design of the buildings around the shop. A small brush dipped in Burnt Sienna mixed with Hookers Green Dark was used for the fine lines of the carvings.

FOCAL POINT ✔
TONE ✔
COLOR ✔
BALANCE ✔

Putting life into a static subject

**Singapore Skyline,
22 x 31" (56 x 79cm)**

From below Benjamin Sheares Bridge one can see an uneven row of high-rise buildings against the skyline of the Central Business District of Singapore.

It is very interesting to watch the light changing from early morning to late afternoon. When painting this scene, I observed the colors of the buildings but tried not to follow too closely what I saw. I normally use a basic color throughout the course of each painting. However, even when I use a common color, some buildings with distinctive colors cannot be substituted.

Care has to be taken when mixing a color to suit the common tone of the painting. For example, the bluish-green of the tall Republic Plaza on the right had to be carefully toned so that the building was not too striking but at the same time convey subtlety. Since the structures were vertical, I needed a horizontal coastline to balance the scene. Some movement in the way of working boats tied up the painting nicely.

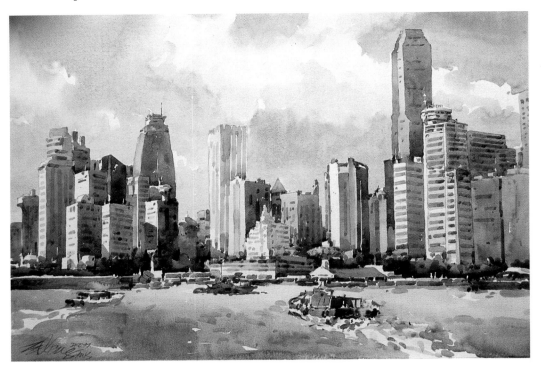

Just a suggestion of the shape of a boat did the trick. Notice how loose the wake is, and how the little accent of red livens this area up.

FOCAL POINT ✔
TONE ✔
COLOR ✔
BALANCE ✔

How to check to see if your painting is really finished

I notice some beginners keep on adding colors until the painting becomes mud — then that painting is really finished! One must to be careful when adding the finishing touches to a painting.

- What I do is to check from top to bottom and from left to right.

- I look for areas that have been mistakenly left white for no reason.

- To fill these white areas I use a color that is compatible with the underlying wash or glaze.

- However, uncovered white areas should not just be covered with the surrounding colors.

- The appropriate tones and values have to be used to correctly project the source of light as well as the focal point. Thus a gradation of colors may have to be used.

Ensuring a sense of balance

**Santa Margarita,
22 x 15" (56 x 38cm)**

This is a scene on the Italian Riviera. I was there in summer, when the sunlight is at its best and I was able to spend long days painting.

To make sure the painting had a sense of balance, I used the building on the right as an anchor point. That way, the distance between the foreground and the hills in the background was clearly defined.

The trees interlock into a dark shape to project the lighter colored buildings in the center.

I used dark greens to project the shadow areas of the building in the foreground.

The focal point is confined to the building with an orange roof.

I painted in the shadows in the foreground to balance with the tree on the right.

The painting has a triangular design with the base of the triangle on the left.

FOCAL POINT ✔
TONE ✔
COLOR ✔
BALANCE ✔

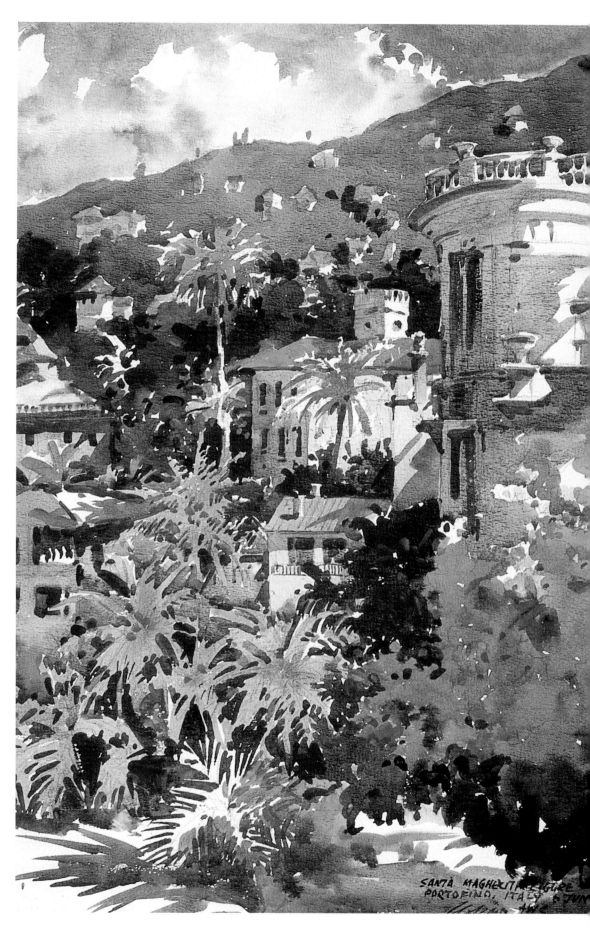

SANTA MARGHERITA LIGURE
PORTOFINO, ITALY 6 JUN

73

Critiquing
YOUR WORK

RATING YOUR PAINTINGS WILL TELL YOU IF YOU ARE IMPROVING OR STANDING STILL. IF YOU HAVE HIGH AIMS YOUR EXCITEMENT WILL RISE ALONG WITH YOUR ABILITIES.

Action Plan!

- Let your painting sit for a time before you attempt to critique it.
- If the painting is dull, introduce life.
- If you have underworked an area, add to it.
- If you have overworked it, lift areas back.
- Exaggerate distinguishing details.
- Observe correct tonal values and optimum contrasts.
- Look for weak colors and strengthen as necessary.
- Compare your works to that of the masters.
- If you really can't correct it — crop it.
- Don't become complacent.

In the last chapter I touched on critiquing your own work. Knowing how to judge your work is just as important as knowing how to paint. It is best to critique your work by yourself and not seek the views of others. The moment you seek advice means you are not sure where the fault lies.

I think the best way to judge your painting is to place your finished piece alongside the paintings you did previously and ask yourself: Is this painting better than the last set of paintings in terms of its color, tonal values, composition, spontaneity, transparency and subject matter? Try giving an A, B, C rating to your paintings. If a painting falls within the A rating then you are going somewhere. If not, you will have to try harder to create a better piece. If you work with this system you will be setting yourself a target to achieve better results, and you will soon find that every day is filled with excitement as you strive to accomplish better quality works.

To be able to draw and paint well takes time, but to sustain this interest is even more difficult because on some days the sailing may not be smooth due to various reasons. Our moods, health, conflicts with family and friends, and even the weather, can affect our painting.

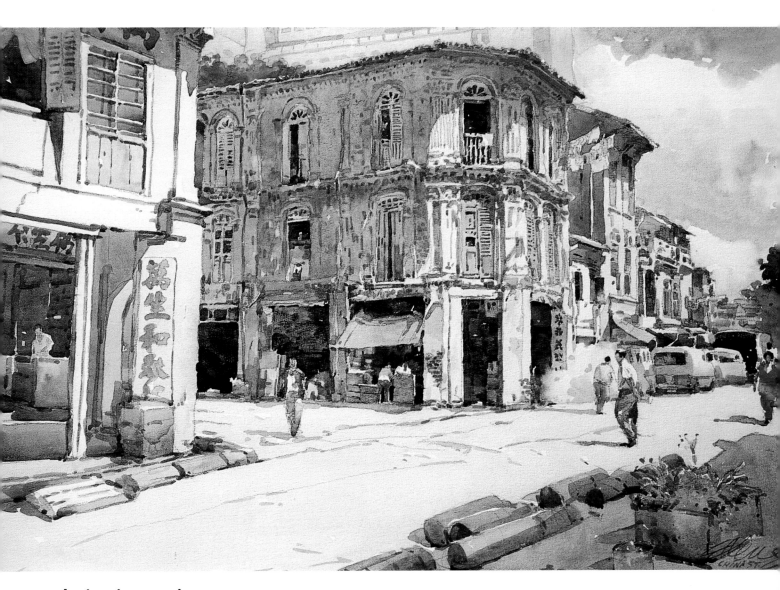

Introducing interesting elements

China Street, Singapore, 22 x 32" (56 x 81cm)

This building, like many other pre-war buildings in the heart of Singapore city, has since been demolished to make way for multi-storied complexes. It is sad to see such old buildings with character going one by one. However, land is scarce in Singapore, and it is unavoidable that redevelopment involves demolition of such interesting old buildings. Most of the time I have to beat the bulldozers to paint these beauties before they are completely wiped out. As a realist, I feel the importance of recording the experiences of my lifetime.

For this painting, the shadows are important because they project the three-dimensional effect of the building. I painted the architectural details as accurately as possible.

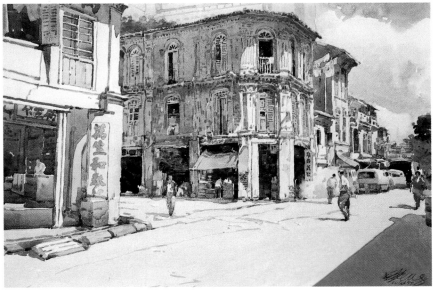

How it looked before I critiqued the painting

When I painted this building, the center area and the foreground were rather bare so I added logs and a flower bed in the shadowed foreground, and a few people in the center, to add life to the scene.

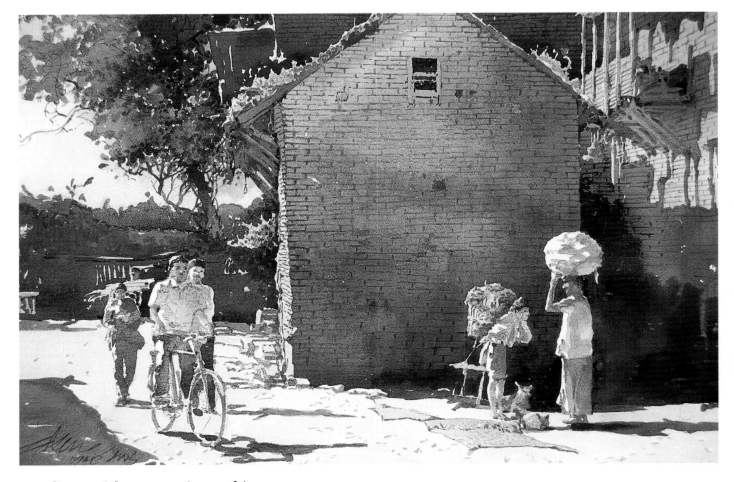

Dealing with two points of interest

After Work,
22 x 31" (56 x 79cm)

The composition here was a little tricky because I knew there could be a problem with having two strong focal points. This painting was about people and I divided them into two groups. The men carrying goods on their heads were in the shadow area resulting in greater contrast, while the man on the bicycle followed by the other two men were in the lighted area, where contrast was less.

I used Mauve mixed with my usual siennas for the shadows, and Rose Madder Red and Cobalt Violet fused with Burnt Sienna and Indian Red for the wall. I did not elaborate on the surroundings because I wanted to focus attention on the two groups of people.

Detail

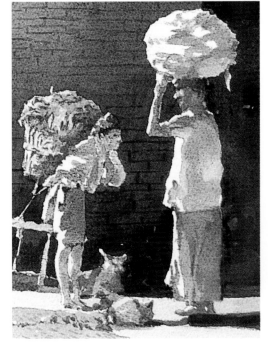

Detail

Pinpointing what's wrong with the painting

Most of the time, despite efforts to liven it up, the problem is a dull or low key painting. Use a painting like this as a guide for improvement and as a reference for future paintings. When I have done a "hopeless" painting, I often tell myself that my next painting is going to be better.

There are times when it is almost impossible to make any corrections to a piece of work. But sometimes, just leaving it alone for a week or two is a good idea because you can look at it again with fresh eyes and may be able to identify exactly what's needed to fix it. New ideas and ways of improving the painting come because our imagination, moods and perception change with time. What at the beginning was a lost piece can still be rescued. Not all failed paintings need to be thrown away.

How can it be improved?

As a last resort, after I have put on more finishing touches or lifted off overworked areas and I'm still not happy, I think of ways beyond the painting to improve it. Sometimes introducing a new element can add life to the work.

In extreme cases I may even crop off an area on the side because of some silly mistakes that are not correctable. An experienced artist once told me about a painting he had exhibited a number of times but it remained unsold. After

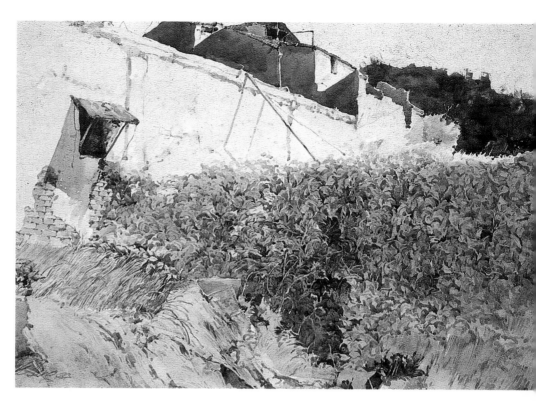

Balancing a difficult composition

Backyard, 22 x 31" (56 x 79cm)

I pass this place very often because it is right in the heart of town along Bencoolen Street in Singapore. The building was due for demolition and when the occupants moved it became overgrown with wild grass and shrubs. I painted this scene one afternoon in company with a few artist friends. It later won an award from the American Watercolor Society's 1988 International Exhibition in New York City.

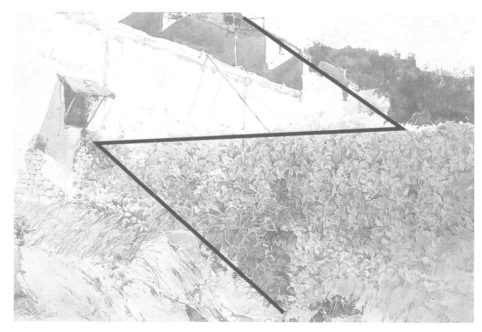

For the composition I painted very detailed scrub and bushes in contrast with the almost bare cement wall at the back. To balance the rather bare top with the bushes below, I painted the shadows of the open window on the building in a much stronger value. The whole painting forms a "Z" composition with alternate light and dark colors.

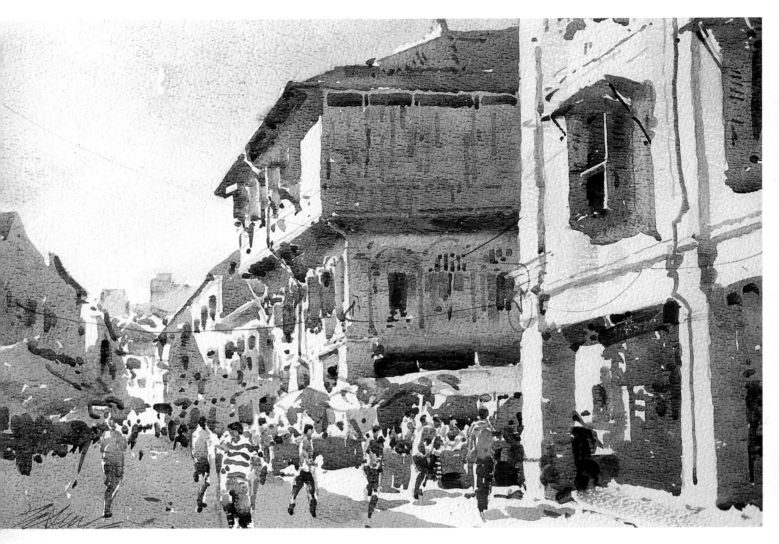

Adding life with color and contrast

**Chinatown, Singapore,
15 x 22" (38 x 56cm)**

Chinatown used to be a painting haven for artists but lately, because of renovation and rebuilding, the area has lost its original ambience. The shops that used to sell provisions, Chinese medicines, clogs, and even coffins, are no longer there. Even the numerous makeshift stalls selling all manner of goods, vegetables, fish and meat have been relocated to the nearby market. The infamous stall that sold snakes, reptiles, bats, wild cats and so on, as delicacies, has disappeared.

In Chinatown I enjoy watching the movement of people walking to and fro in the narrow lanes, and I love the verandahs that stretch from one end of a building to the other.

In this painting, I left areas in the sunlight white paper and painted the weathered walls of the buildings and the distinctive pillars with a strong dark Iron Oxide Red mixed with Cobalt Blue. To add life to the painting, brighter colors were used for the people's clothes.

examining the painting he discovered that the right side was not in balance with the left. He promptly cut off the right side and the result was a marvelous painting which was sold a week later to a collector who happened to visit him. This may not be the normal way to solve a painting problem but if it works, why not do it?

I seldom overlook an area that is over- or underworked. Perhaps a tree looks weak once the painting is completed. I ask myself which aspect of the tree does not look convincing as a particular species.

For example, which part of that coconut tree could I improve to distinguish it as a coconut tree? I may have left out small but important distinguishing details.

Another important area to check concerns the tonal values used in the painting. I usually look for colors that are not intense enough, in which case perhaps another layer would be necessary to achieve the required tonal value.

At the same time I check for contrast, which may not be strong enough to create the required impact.

When I check my paintings

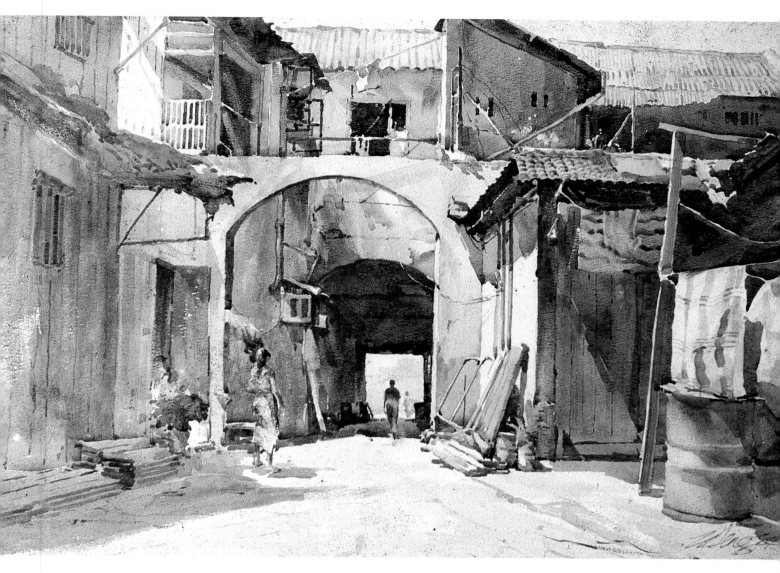

Creating the illusion of distance with figures

Lane in Singapore, 22 x 31" (56 x 79cm)

I used an "X" composition or a three-point perspective to paint this scene in what was once Middle Road, Singapore. The place no longer exists, having been supplanted by tall buildings.

After sketching with a 4B pencil I started painting from the top center to the right. Then I painted the sky, followed by the rooftop. I applied heavier colors for the structures on the right and the laneway, which became the focal point.

Using a tone of Raw and Burnt Siennas for the main colors I depicted the weathered walls and the aged structure.

I put in the two figures to convey the distance between the entrance and the end of the corridor.

Old buildings are more interesting and easy to compose. I have a hard time getting an interesting composition when I paint modern buildings, especially the ones that resemble cardboard boxes.

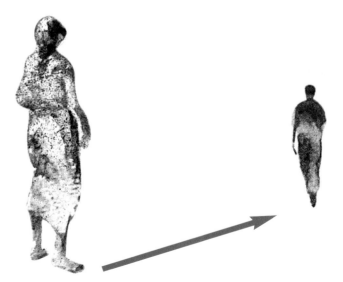

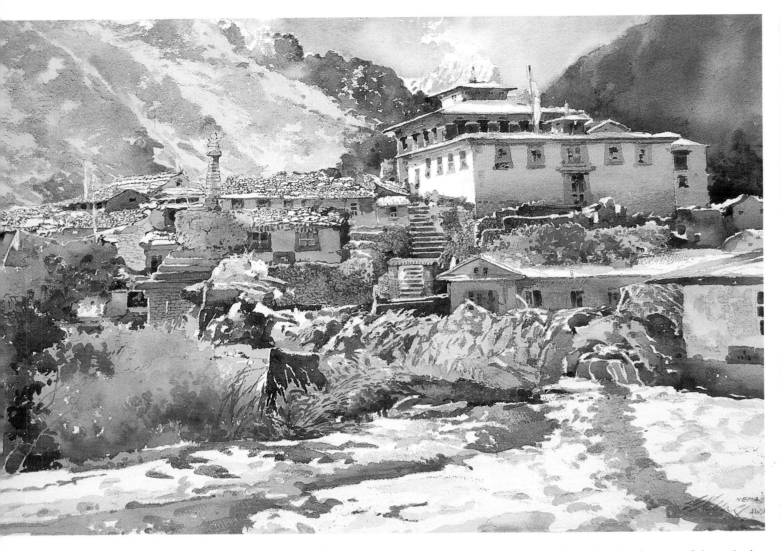

Avoiding problems in the first place

Thyanboche Monastery, Nepal, 22 x 32" (56 x 81cm)

I camped just behind this Monastery at Thyanboche to find some shelter from the strong gales that blow through the valley. I was lucky to find a kitchen at the back of the yard which was only used during festival times, especially the Mani Rimdu between May and June. During this festival the mask dance is performed at the open space in the center of the Monastery.

I sat on my stool under a yak shade to paint this place of solitude in late fall. I checked that colors were right and the point of interest well-focused. I love fall colors. I can feel the richness of the reds, oranges and yellows.

For this painting I worked with a combination of Chrome Orange, Burnt Sienna, Raw Umber, Raw Sienna, Cadmium Yellow, Ultramarine Blue and Alizarin Crimson Permanent.

When I evaluated this scene, the main building and the cluster of smaller houses appeared cluttered. To avoid making everything in the composition too busy, I did not add any details to the mountains and foreground except for some dark defining lines.

I often think of successful works by other artists, especially the master watercolorists. If I can compare a painting by a master from books and magazines it definitely helps. Studying a master's works can inspire you to paint the subject again, but this time you can adopt certain ideas and colors. I compare the colors of the finished painting with that of the masters and gauge how close my painting is with theirs. Masterpieces by past painters are the result of years of valuable experience, so why not learn from them?

One pointer that something is not quite right is when friends and critics ask me what is so special

Manipulating color for mood

Façade, Singapore,
22 x 32" (56 x 81cm)

This is the façade of an old Straits Chinese building by the side of the Singapore River. It is a very simple subject, but a simple subject may not necessarily be simple in the eyes of an artist!

Looking at the weathered surface of the aged planks and the eye-catching damaged pediments, I could feel the building's glory of yesteryear.

For this painting I used a limited palette of a grayish tone for the façade and brighter colors for the unruly plants and weeds growing on the surface of the wall. The gray was a mixture of Cobalt Blue and Payne's Gray. I did not use strong contrasting shadows for this painting because I wanted to convey a mood of loneliness and abandonment.

about a particular painting and I am not able to give them a positive reply. But if I have fulfilled the requirements of a good painting and am able to answer them positively, then my objective of impressing the viewer is achieved.

The saddest thing that can happen to an artist is when they become content with all the work they produce and believe that every piece is a "masterpiece" of some kind. This type of artist does not invite criticism because they prefer praise. Quite a number of artists fall prey to this complacency, which is not a healthy sign in terms of advancement and progress. ☐

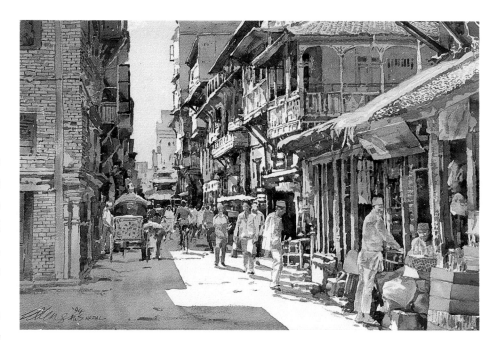

Leading the eye with color, light, shadow and shape

Market Place, 22 x 31" (56 x 79cm)

The city of Kathmandu lies at a height of about 4,264 feet (1,300 metres), which gives it a temperate climate. I stayed at a small hotel in the heart of the city. In Kathmandu, the sunlight is very distinct and the sky is clear even on a fall day. Like any marketplace in Asia, the early hours of the day bustle with activity so I painted this scene with the idea of people and activity in mind.

The earth colors of the buildings matched very well with the figures in the painting. I concentrated on the movement of the people in the center and added the red to draw the viewer's eye to that area of interest.

The shape of the main shadow on the left, and the perspective of the buildings on the right, help lead the eye straight to the focal point.

Luminosity and Contrast

Action Plan!

- Achieve luminosity and contrast.
- Leave white paper for the brightest lights.
- Glaze surrounding whites.
- Create strong, rich darks infused with subtle color for the shadows.

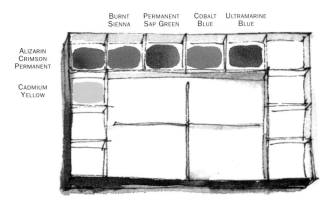

ALIZARIN
CRIMSON
PERMANENT

CADMIUM
YELLOW

BURNT
SIENNA

PERMANENT
SAP GREEN

COBALT
BLUE

ULTRAMARINE
BLUE

The scene, Aliwal Street, Singapore

This is a photograph of an old back lane in Singapore's Aliwal Street at about 10:30 in the morning. These old houses are rare survivors in Singapore because most old buildings have been demolished to make way for more modern ones, like those in the background. The houses pictured here are also scheduled for demolition, so I decided to paint them before they disappeared forever. The back lanes of such old houses, with their characteristic clutter of usable and unusable objects and paraphernalia, make good subjects. This one has a makeshift kennel in the foreground. On this particular morning, the sun was bright and the shadows strong — it was a good day for painting.

details

I usually mix a neutral color for the shadows so that whatever color glaze I add later does not create conflict in the color scheme. So, for example, I would apply a warm color over a cool color, or vice-versa. You will only get ideal results and proper control by practicing glazing.

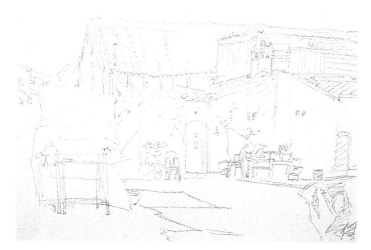

Preliminary sketch

I made a sketch of the scene using a 4B pencil. This scene is not too complicated, but the composition still had to be carefully designed because this is the first step in presenting the painting.

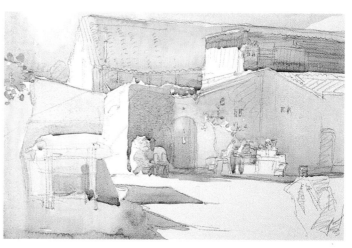

The first wash

Having decided on the areas of contrast I could begin painting. I laid a light wash on the areas in shadow, leaving the paper white in the lighted areas. Because of the heat of the day, I often work very fast, painting from the top to the bottom of the paper.

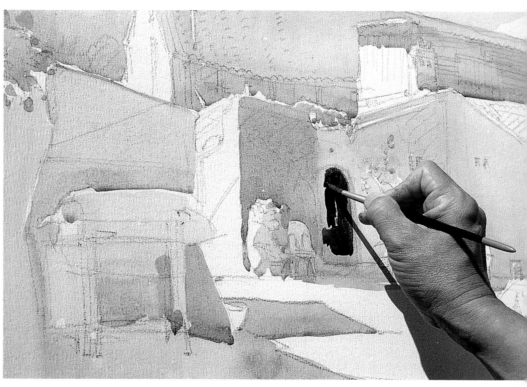

Establishing the focal point

I began to paint the most interesting spot, the focal point of the painting, the small doorway, with a mixture of Burnt Sienna and Ultramarine Blue using a #6 brush. I also made sure that although this small area was dark, there were objects in it so that the result was not just a flat wash of dark color.

▶

Important things to remember before you start

- Always make yourself comfortable before you start to sketch the outline. Ideally one should set out early in the morning because sometimes the weather can affect the progress of the painting.

- Before you start, always pinpoint the darkest darks and the brightest points.

- Edit those parts of the scene you do not wish to use. In this case, I omitted the smaller clothesline, the helmet on the kennel, the bicycles and, of course, the modern buildings in the background.

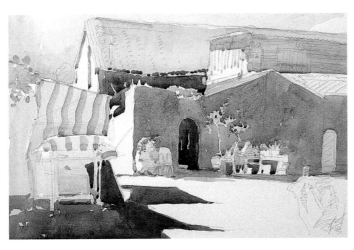

Painting the shadows

After finishing the darkest point in the painting, I moved on to the shadow area of the house and the board against the kennel in the foreground. The colorful sheet hanging on the line was painted with a light Ultramarine Blue and the cloth draped over the kennel was a light Alizarin Crimson Permanent.

I added a wash of Permanent Sap Green and Cadmium Yellow for the plants near the building. By this time the shadows had changed their position, but because I had sketched their outline earlier on, I had a plan to work with. I painted the shadows with a mixture of Ultramarine Blue and Burnt Sienna.

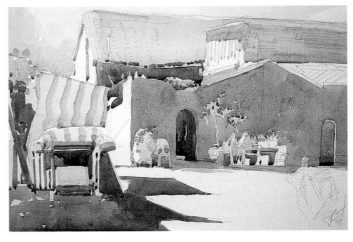

Introducing the foreground darks

The other dark areas in the foreground were painted with a mixture of Burnt Sienna and Cobalt Blue. For these washes I used a #6 brush — the size I often use to paint smaller areas. The lines of the kennel were deliberately broken to suggest uneven shadows.

The first doorway was to be the focal point of the painting so to keep it that way I used a lighter, unobtrusive wash for the second doorway.

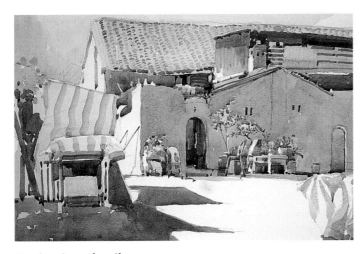

Getting into details

I added the lines in the foreground for the kennel, then concentrated on the shadow areas below the roof in the center of the painting. The extension on the right top corner of the painting was also painted.

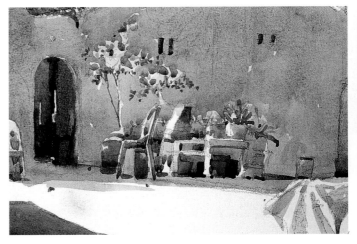

Detail

I added another glaze for the doorway, as well as the areas beneath the potted plants. Then I put in the details of the plants and painted the tones, wrinkles and creases on the piece of cloth in front.

Finishing off and checking balance

Some branches were added to the left corner of the painting after I eliminated the modern buildings at the back of this old house.

The plant, the covering of the kennel, more details for the wall and the areas beneath the roofs, the tiles of the roof as well as the rusted zinc roof were painted with care. Each step in adding the details was executed after careful and accurate observation of the scene on site.

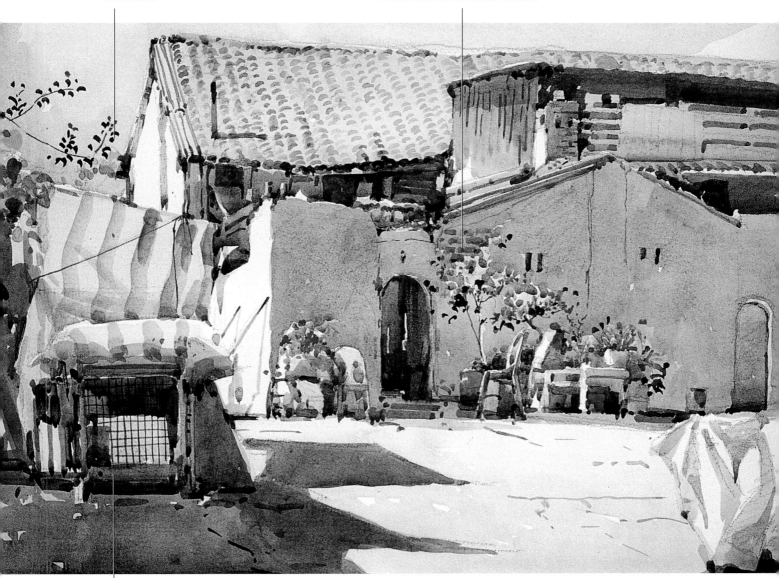

More details were added to the kennel as I worked my way over the painting from left to the right.

Once the painting was completed was the time to check whether the focal point was clearly defined. To do this, I viewed the painting from a distance to see if both sides were well balanced.

Remember

Every painting is an expression of how you think and feel. Before the start of every painting go through a mental exercise on how best to work on the painting so that it will be something that will not merely catch the viewer's eyes — it will be something that will make them stop and look, something that creates a reaction!

Working with a light and shadow plan

Action Plan!

- Work from dark to light.
- Stick with a shadow plan.
- Control overall color for harmony.
- Use color to show the distance between objects and structures.
- Fuse colors.
- Pay attention to brushstroke application and wrist action.

The scene
Changi
Here I am on site enjoying painting this traditional scene.

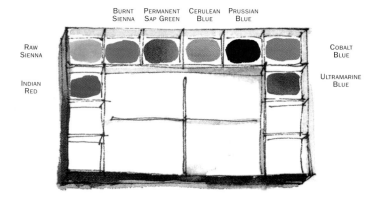

Controlling color
Next I added in the darker tone for the side of the jetty adjacent to the two foreground boats. These darks enhanced the jetty pathway which I left white until I painted the planks.

My accurate preparatory drawing
If you look carefully you will see that I had faintly shaded the areas that would be in shadow.

Establishing the shadow plan
For the first wash of color I used a pale Raw Sienna to indicate the shadow areas indicated in my sketch. While applying this wash I emphasized the areas where bolder strokes would be needed.

Introducing darker tones
I had to be careful that the intensity of the color applied to the jetty and the planks did not overpower the objects in front. Notice that I am using a largish brush for this work. Larger brushes stop you from fiddling with detail.

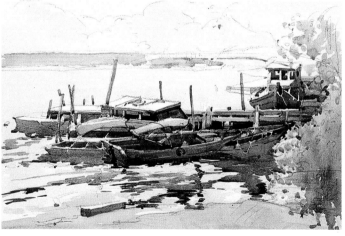

The story so far
When the jetty was completed I continued to paint the boat in the top right corner, using a mixture of Cobalt and Cerulean Blue to suggest distance. Next I painted the bank of the river in the background.

I used #10, #6 and #2 brushes for the dark lines of the boats and the old jetty. The application of force on the strokes is very important, involving control of wrist movements and heavy and light touches of the brush. The amount of water added to the color makes a great difference — for lighter areas I add more water, for darker areas I use less water.

Detail

This is a close-up shot of the boats in the foreground and part of the jetty. Notice the areas where I fused two colors to show the difference in tones. To create the reflection of the two boats in the foreground, I fused Ultramarine Blue, Indian Red and Burnt Sienna.

Developing the water

Next I painted the water in the distance and the boats in the background. I then introduced some movement into the water using the same colors for the distant water and the boats. Then I moved on to enhance the reflection of the boats. I used the darker tone used for the boats in the water.

Introducing the trees

The painting was completed by adding the dark shaded areas of the trees using Prussian Blue mixed with Permanent Sap Green. At this point I checked the areas where the shadows had been left out. These areas included the bridge in the background, some parts of the boats and the trees in front. Instead of using the same dark mixture for the background to paint the shadows in front, I mixed a color by adding a darker tone to the color of the earlier washes. For instance, if I used a wash of Burnt Sienna and Indian Red for a boat, to make a darker tone I added Ultramarine Blue.

The finished painting

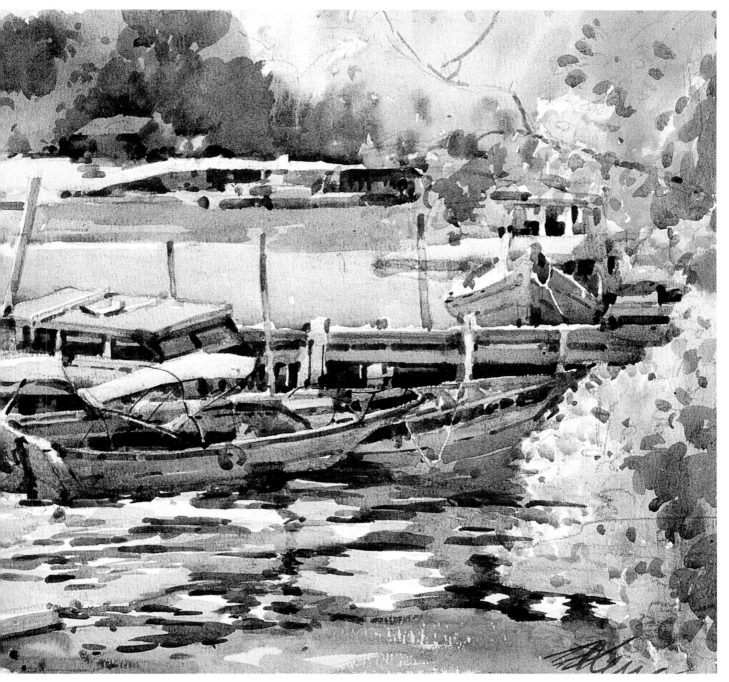

Action Plan!

- To show this unique subject in dramatic contrasts of light and shade using carefully orchestrated color.

- To choose a focal point and stick to it, even though there are two points of interest.

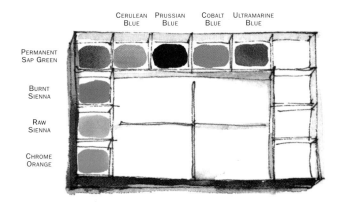

The scene
Telok Ayer Festival Market, Singapore
This market, designed by G. D. Coleman, was completed in 1836 and is of local historic significance. I chose this as a subject because of its unique architectural design.

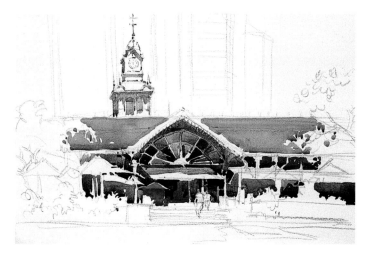

Painting the roof
Using a light mixture of the Burnt Sienna and Chrome Orange, I painted the roof. For the clock tower, which is identified with this famous building, I used a grayish mixture of Ultramarine Blue, Raw Sienna and Burnt Sienna. I strengthened the strokes on the corners of the tower.

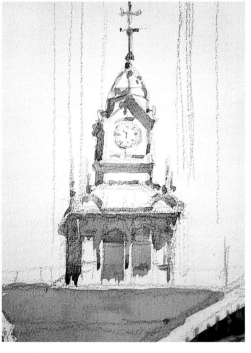

Detail of the clock tower
This is a close-up of the areas I left white which intensify and strengthen the sunlight. The advantage of leaving (reserving) white paper in watercolor is that it allows the artist to explore and enhance the play of light.

o enhance the effect of early morning light

The drawing

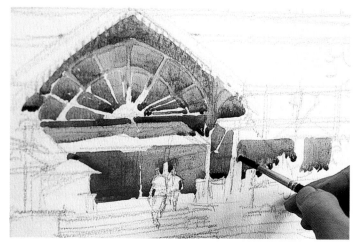

The first wash

Very often I begin the first wash in the area that appeals to me most.
In this case I mixed Cobalt Blue and Cerulean Blue for the interior of the market, and then I used Burnt Sienna and Chrome Orange for the shadow areas of the roof support and the shade. The blue interior gives a cool feeling to the painting.

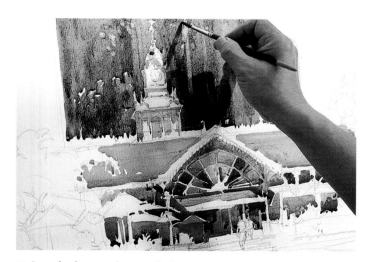

Using dark to enhance light

To project the clock tower, I painted the background buildings a dark mixture of Burnt Sienna, Cadmium Orange, Prussian Blue and Sap Green Permanent.

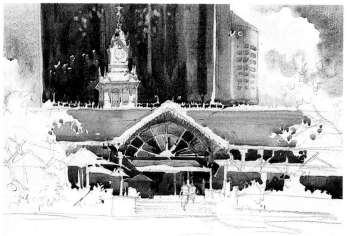

Lifting off a defining line

At the same time, I fused this mixture with Ultramarine Blue on the top left corner. When the colors on the buildings were half dry, I washed off a thin line with clear water to show the demarcation between the buildings.

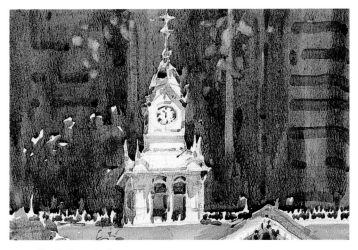

Detail of the clock tower

As you can see, the clock tower was then clearly defined. The white spots to the left of the tower represent the characteristic birds, which I left untouched while painting the buildings. The line that I washed off can be clearly seen on the right side of the tower.

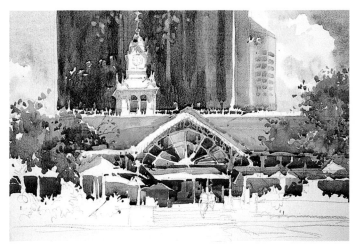

Introducing the trees

The trees on both sides of the entrance were added to the painting. When I painted the trees, I used different tonal values for each tree to achieve a sense of distance between them. Furthermore, I took care not to make the shapes of the trees identical.

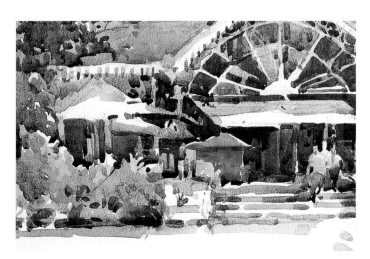

Detail of the step area

This close-up shows the shadows and the lighted areas. I included the figures to create movement. The red vendor's hut gives strength to the focal point.

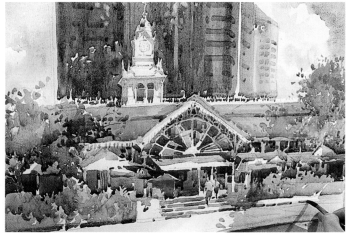

Enhancing the shadows

After painting in the details of the trees, the vendor's hut and the steps, I concentrated on the shadows. For these I mixed a light gray using Ultramarine Blue and Burnt Sienna.

The finished painting

Although I emphasized the entrance and the clock tower, the focal point is still the entrance because of the strong red of the vendor's hut on the left. To indicate that this painting was done in the morning, I placed long shadows and left some areas white to suggest the light of the early morning sun.

Detail of contrast in tree on the left

Notice the darkened areas which bring out the contrast between the roof and the leaves in the center.

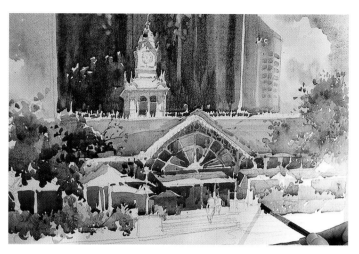

Working on the supporting foliage

I painted the plants below the tree on the left and then, using a lighter green than the mixture for the tree on the right, I painted the plants cascading over the wall on the right.

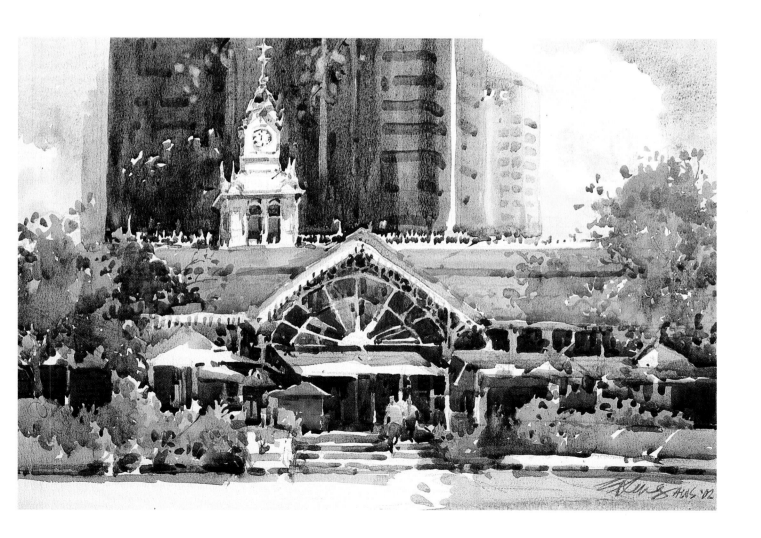

Action Plan!

- Draw with the brush.
- Begin with the darks.
- Strive for luminous transparent washes.
- Suggest life and activity.
- Emphasize the people with color.
- Show reflected light.
- Exaggerate contrast between light and shade.

The scene

Old Street, Singapore

It was an overcast day when I sat down to paint this scene in an old part of Singapore. I had to wait patiently for the appearance of the much needed sunlight. In Singapore, the weather changes constantly, so I believed there would not be a problem with the sun and began sketching the scene.

Drawing with the brush

For this sketch I used a #3 sable dipped in diluted Raw Sienna. Due to the overcast sky I did not outline the shadows because I was hoping the sun would appear and cast the much hoped for shadows. It is usually as a last resort that I have to imagine the light and shade for a painting.

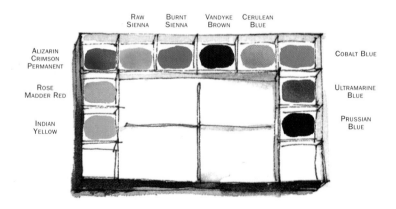

ALIZARIN CRIMSON PERMANENT

ROSE MADDER RED

INDIAN YELLOW

RAW SIENNA | BURNT SIENNA | VANDYKE BROWN | CERULEAN BLUE

COBALT BLUE

ULTRAMARINE BLUE

PRUSSIAN BLUE

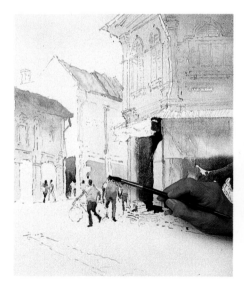

Achieving movement

A sense of activity and life now pervades the picture. Finer details, such as a darker brown for the man's hair, were added to the center of interest.

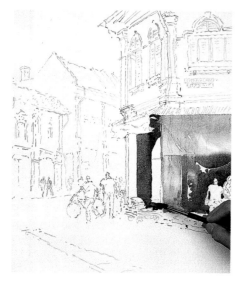

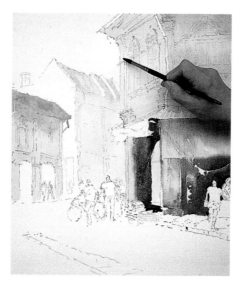

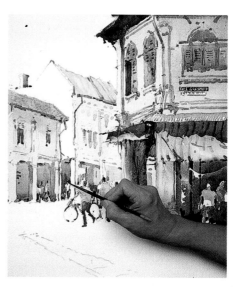

Starting with the darks

While waiting for the shadows to appear and show more contrast, I painted the dark areas in the scene. In this way not much time would be wasted waiting for the sky to clear. I left the figures white, intending to decide on the colors when the sun appeared. For the dark areas I used a mixture of Ultramarine Blue, Alizarin Crimson Permanent and Burnt Sienna. For the pillar and the canvas I used Cobalt Blue mixed with Raw Sienna. Notice the Indian Yellow spot on the right — this breaks the monotony of the dark brown that dominates the shadow areas.

Getting the first wash right

This can sometimes pose a problem. You have to consider whether the color fuses well with other colors. When the second layer is glazed on a wash, you must make sure that the result is a clean transparent overlay. This is the reason why knowledge of tonal values and color density is very important.

Introducing the people

A painting of an old street without people is static and looks unreal. Because the people would become part of the area of focus, I used bright colors for their clothing.

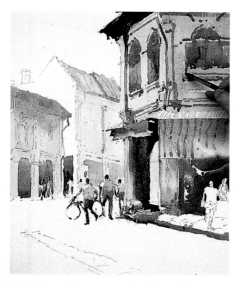

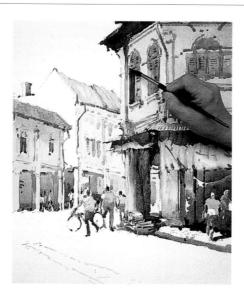

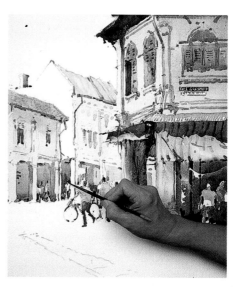

Thinking about my shadow plan

I painted the canopy and the shade of the stall with Cerulean Blue and a little Raw Sienna. The roof and drainpipes were painted with a Vandyke Brown and Prussian Blue mixture. It was important to emphasize that part of the pipe nearer to the roof with darker colors because this was where the roof and pipe met in the shadow area.

Painting the windows

The windows were painted at the same time as the roof. I used a pale mixture of Cerulean Blue and a little Cobalt Blue. Next I added the window frames. I painted the half-opened window with a mixture of Prussian Blue and Raw Sienna. The lines on the right side of the window were painted darker to suggest the depth of the interior of the room.

Thinking about reflected light

Using this same mixture, but with Rose Madder Red added, I painted the verandah on the opposite side of the street. The reason I introduced red was to show the reflected light from the road.

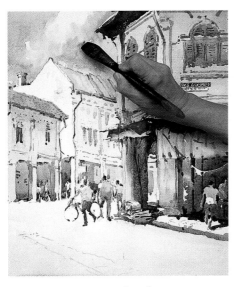

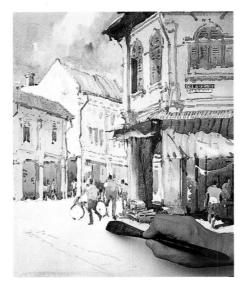

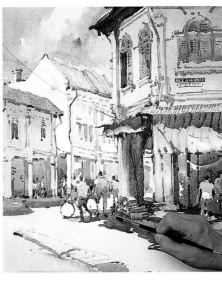

Making a start on the sky

Before I continued with the details, I painted the sky. In a scene like this it is usually safer to paint the sky first, but instead, because of the poor light conditions on the street and the buildings, I painted the dark areas of the building first. In this way I was able to maximize my chances of getting better light for the clouds and the scene as a whole later on.

Suggesting dazzling sunlight

The road was then painted with a very pale Raw Sienna wash, almost paper white, to show the intense sunlight cast on the street.

Developing the foreground

With a little mixture of Cerulean Blue and Raw Sienna and using a dry brush stroke I painted the weathered wall in the foreground. I have to make sure that the mixture on the brush is not too wet to render a successful dry brush stroke. Then I began on the deeply contrasting shadow areas. It is the darks that emphasize the light.

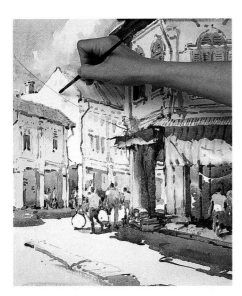

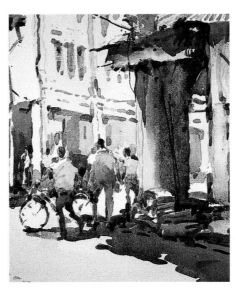

Putting in important details

After evaluating the painting I worked all over adding important little details. It is as important not to underwork as it is not to overwork.

Detail of the figures

Notice the highlight on the shoulder of the man with the red shirt.

The finished painting

I added cracks on the road and the covered drain in the foreground. As you can see, the emphasis is on the three figures in the middle of the painting. Notice the sharp contrast between the sunlit areas and the shadow areas. In the original scene such a contrast is hardly noticeable. I would like to emphasize that "dramatization", that is, exaggeration in color, composition, or in any of the other aspects of painting, may be necessary to create a lively painting with staying power.

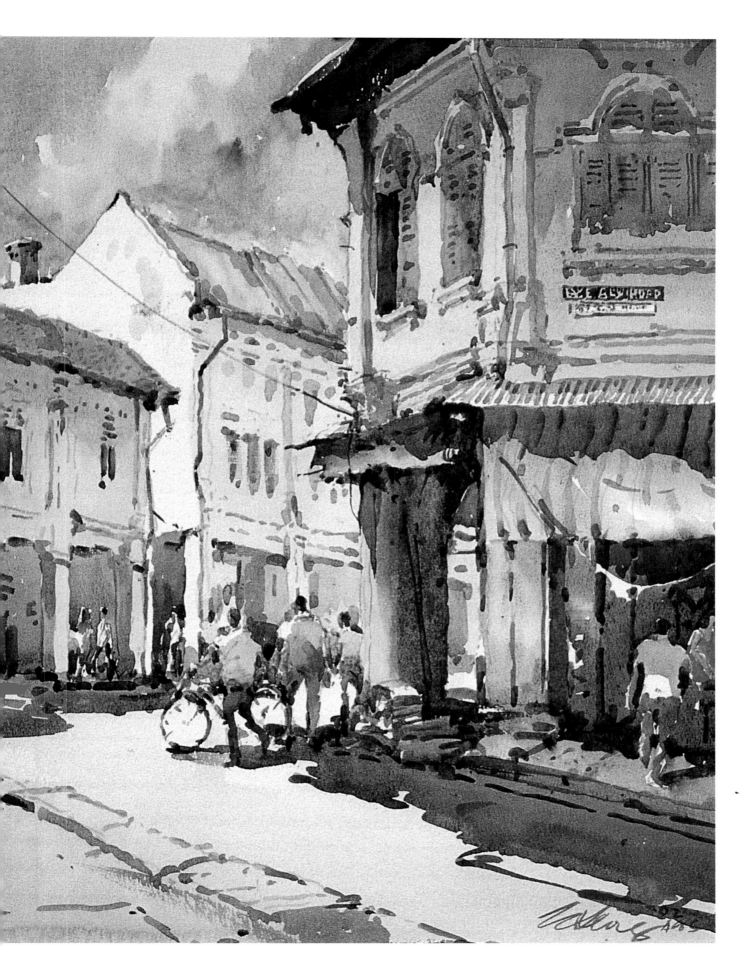

Developing the darks to enhance

Action Plan!

- Show a luminous morning sky.
- Use reflections and ripples to create movement.
- Reserve white paper and place strong darks to enhance the feeling of light.
- Play with warm and cool color to add interest and variety.
- Create a background that, while not flat, will not compete with the focal areas.

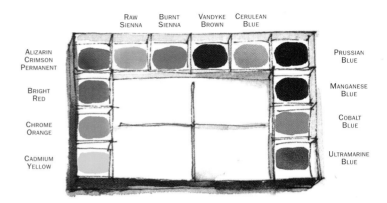

The scene

Melaka River, Malaysia

The first time I painted the Melaka River was in 1963. This legendary river is the soul of the city and flows through its heart. Whenever I paint the Melaka River I am always reminded of an incident which happened back in the 60s. While I was painting I heard someone behind me saying in a Chinese dialect "Suppose we push this chap into the river and see what fun we can get!" I turned around and saw two fierce looking thugs standing behind me. I just kept painting and did not look back again. After a while nothing happened and when I turned around there was no one in sight. What a relief! This is the same spot I painted in 1963 although the place has undergone great changes.

Drawing with watercolor

I sketched the outline directly with diluted Raw Sienna watercolor.

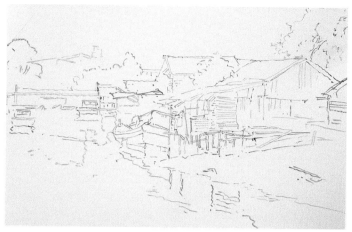

The completed drawing

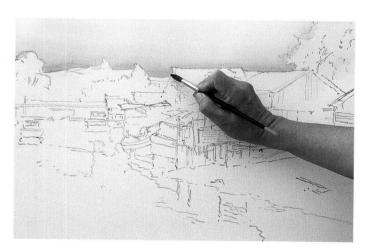

Beginning with the sky

For the morning sky I fused color on the paper — Cerulean Blue at the top merging into Cadmium Yellow then Bright Red at the bottom.

I gently used a #7 brush to paint from left to right allowing the paint to flow downwards.

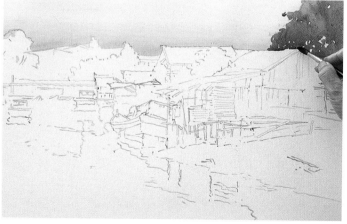

Introducing trees

After allowing the sky to dry, I added the trees using a mixture of Prussian Blue, Burnt Sienna and Chrome Orange. I left some areas unpainted to allow the sky to show through the leaves. The branches were painted with a thin mixture of Ultramarine Blue and Burnt Sienna.

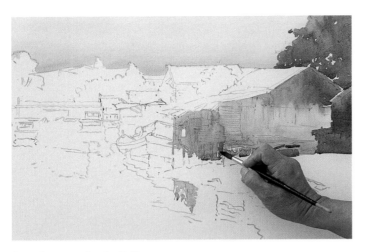

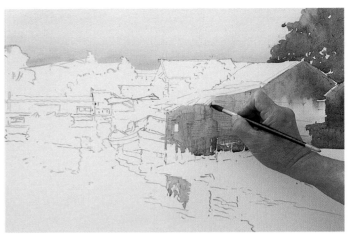

Starting on the buildings

Using a mixture of Manganese Blue and Chrome Orange, which I fused with Alizarin Crimson Permanent, I painted the house by the river. For the house on the extreme right I mixed a dark purple and Raw Sienna to suggest a misty appearance to contrast with the main house.

Creating separation

The line between the wall and the roof had to be clearly defined. To achieve this I wiped away the excess paint that bled into the roof area.

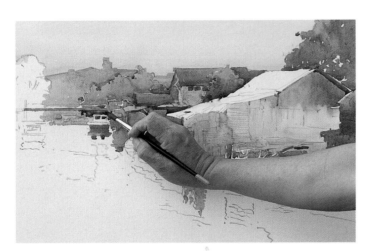

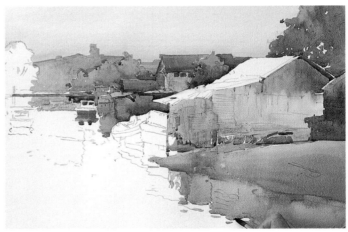

Creating contrast

To project the house, I darkened the edges between the house and the one in the center. I added a glaze of a darker mixture of Cobalt Blue and Burnt Sienna for the edge of the water and the side of the huts in the center.

Defining and projecting the boat

After painting the boat and the bridge I used Prussian Blue and Alizarin Crimson Permanent as a background to project the boat.

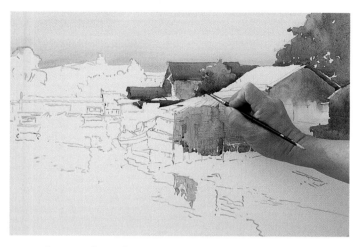

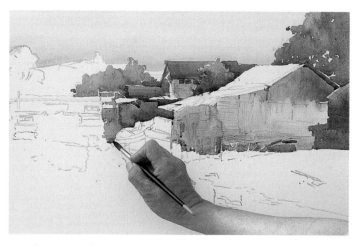

Warming up the color temperature

The house in the background was then painted from top to bottom ending on the side with the tree. You will notice that I adopted a warmer color tone for the building and the tree in the background by using a mixture of Alizarin Crimson Permanent with Burnt Sienna, which I fused with light Cobalt Blue. I painted from the roof to the side wall of the house.

Placing more huts

The row of low huts was next. These I painted with a mixture of Vandyke Brown with Prussian Blue, and a little Cobalt Blue between the washes.

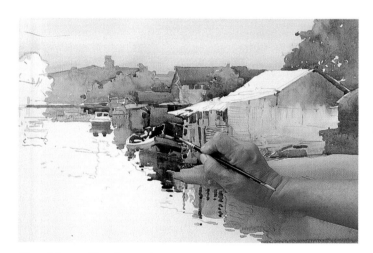

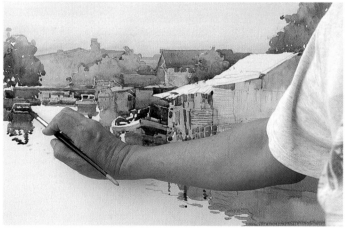

Matching reflection color

Using a mixture of Raw Sienna and Cerulean Blue I painted the reflection of the foreground house. I had to make sure that the color of the reflection and the house did not vary too much. Even if the color of the reflection was darker than the actual object, the color scheme had to be related to the color of the house.

I moved on to the boat in the center of the painting. I used a darker tone for this — a Cobalt and Manganese Blue mixture for the boat and violet and Burnt Sienna for the darker areas. I left some white to show the light areas.

Varying color

The boat on the left and its reflection were painted with Indian Red and Cobalt Blue. I tried not to duplicate colors too much because this could have resulted in a flat background.

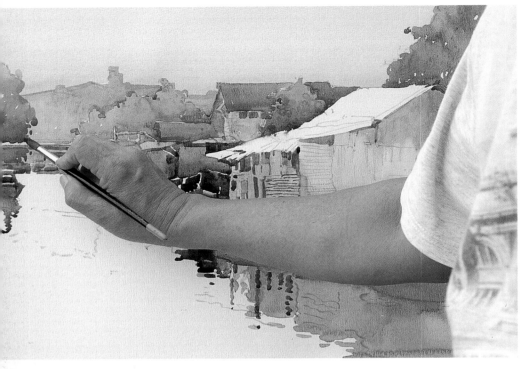

Developing the darks

I used a stronger color for the edge of the tree on the left and the same color to enhance the light areas of the bridge.

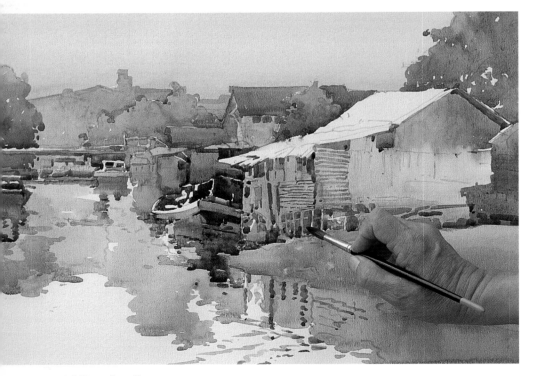

Adding details

For the details of the house in the foreground and the dark areas under the stilted house I used Burnt Sienna mixed with Ultramarine Blue.

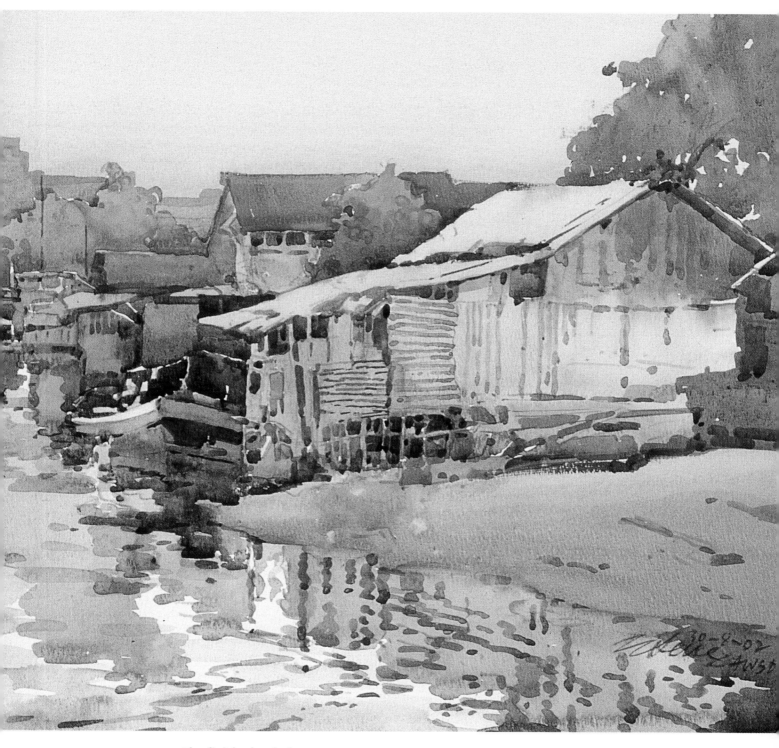

The finished painting

To show movement on the water I used the same colors as for the
dark areas. I then darkened the house on the extreme right. In this
way the focal point, the house in the foreground, was set.

ART IN THE MAKING Balancing color, light and shade

Action Plan!

- Suggest the mood of a sunny morning.
- Make a definite shadow statement.
- Capture character.
- Control color.
- Create the illusion of scale, depth and perspective.

The scene
The Stadthuys

The Studthuys was built in 1650 as the official residence of Dutch Governors and Deputy Governors in the state of Malacca, Malaysia. It is a fine example of Dutch architecture. Preserved in its original structure and form, it now houses the Historic Museum and Ethnography Museum. This clock tower is identical to the Stadthuys.

Making a pencil drawing

It was a very warm morning when I began sketching this tower. I used a 4B pencil to draw the outline.

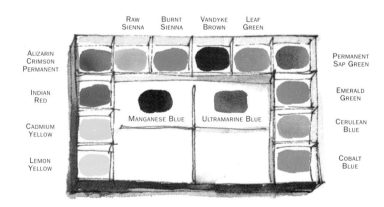

	RAW SIENNA	BURNT SIENNA	VANDYKE BROWN	LEAF GREEN	
ALIZARIN CRIMSON PERMANENT					PERMANENT SAP GREEN
INDIAN RED		MANGANESE BLUE	ULTRAMARINE BLUE		EMERALD GREEN
CADMIUM YELLOW					CERULEAN BLUE
LEMON YELLOW					COBALT BLUE

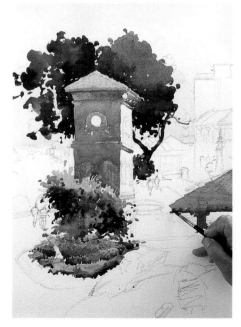

Planting flowers

After painting the trees I added the flower bed. In the actual scene these were very bright and distinct. However, I did not want the flowers to overpower the scene, so I controlled the color. The roof of the building was painted with an orange mixed with Burnt Sienna and Permanent Sap Green. For the roof support I use a dark Burnt Umber and Ultramarine Blue.

Starting with the sky

I painted the sky first with a light Raw Sienna and with more water added in for the clouds. I immediately painted the surrounding areas with a mixture of Cobalt Blue and Cerulean Blue for the blue sky.

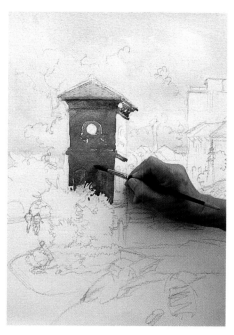

Going straight into the darks

I painted the roof with a light orange and the shadow areas of the clock tower with a mixture of Indian Red, Alizarin Crimson and Burnt Sienna. In this way I painted the clock tower from dark to light instead of the other way round. I did this because the shadow areas were broad and long.

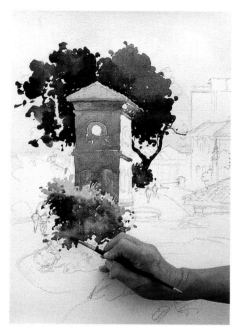

Introducing contrast into the focal point

I mixed a dark green (Hookers Green Dark, Emerald Green and Permanent Sap Green) for the foliage surrounding the tower. I added the plants using a brighter variety of greens (Lemon Yellow and Leaf Green) and for the shadows I used Manganese Blue and Cobalt Blue.

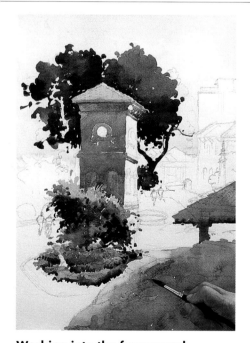

Working into the foreground

The pillars of the building in the foreground were half hidden by the slope in front of me, which I painted with a Permanent Sap Green fused with light Raw Sienna mixed with Bright Red.

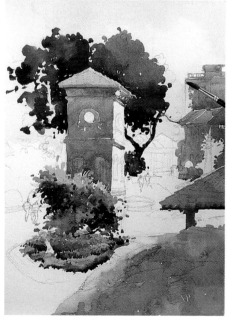

Filling the scene

The buildings in the center right of the picture were painted with a faint mixture of Raw Sienna, Indian Red and Burnt Sienna, while the building in the distance was painted with a mixture of Manganese Blue, Cobalt Blue and Alizarin Crimson.

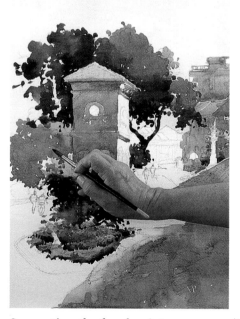

Supporting the focal point

For the tree on the left side of the tower, I used a mixture comprising Lemon Yellow and Emerald Green for the top portion, fusing this mixture with Australian Turquoise and Cadmium Yellow for the lower portion.

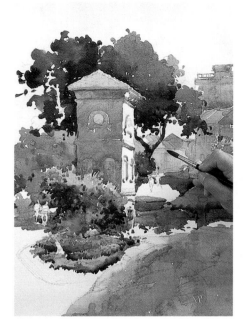

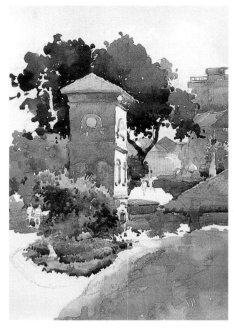

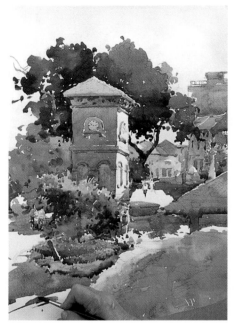

Playing with tone

For the shadows on the ground I used a rich Ultramarine Blue, Alizarin Crimson Permanent and Manganese Blue mixture. I achieved recession by painting the background buildings in a light, unobtrusive tone.

The story so far

Notice how the light is definitely coming from the right. To show morning sunlight, the shadows have to be distinct and accurate.

Placing helpful shadows

Notice how the shadow in the foreground has a stroke jutting out to depict the shadow of the branches of the tree. Long shadows help tell the time of day.

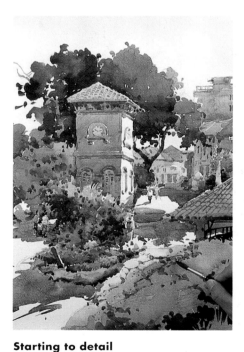

Defining the foreground

Using Vandyke Brown and Burnt Sienna I drew the cracks and stones near the entrance to the Stadthuys. I painted the shadows of the plants using the same colors as the branches above the tower.

Notice the blue that I used for the shadow areas. The figures give an indication of the height of the tower and their varying heights aid the illusion of perspective.

Starting to detail

I began to balance my painting by putting in the details on the clock tower. Using reds similar to the clock tower colors I painted the details on the clock and the windows. Then I developed the foreground bushes. Using the colors for the branches above the tower but diluting with clear water and adding Permanent Sap Green, I added the greenish color for the shadows on the slope on the right bottom corner. Then I painted the windows and the details in the shadow areas.

The finished painting

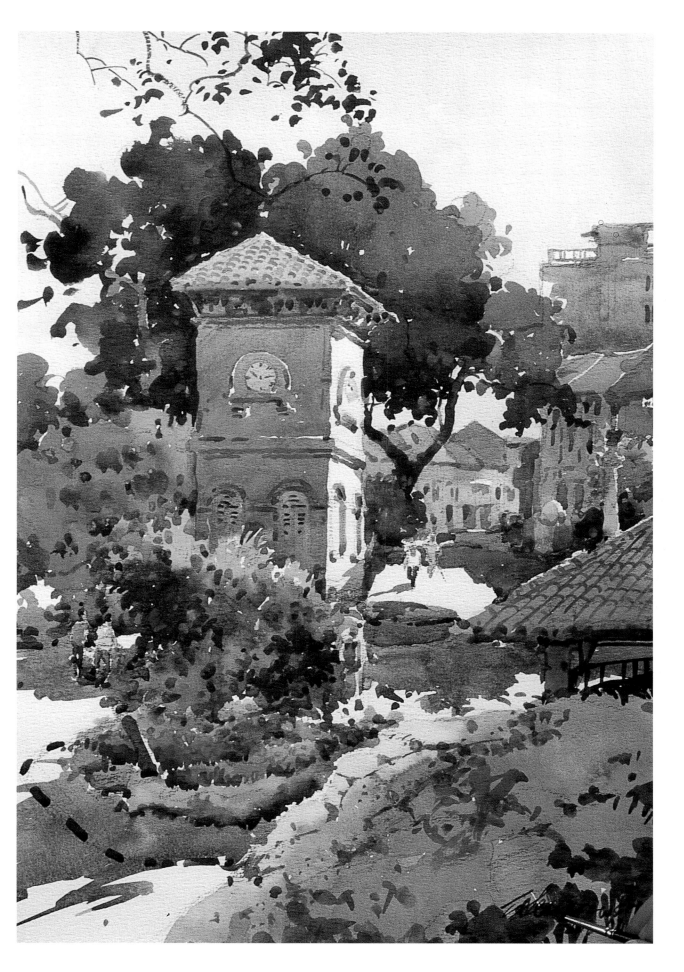

Handling light and shade

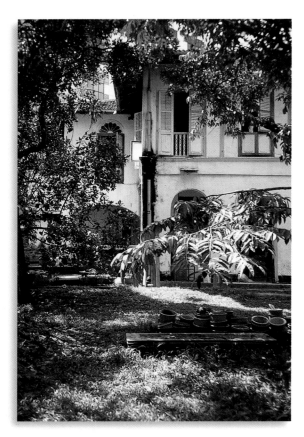

The scene

Mitre Hotel, Singapore

Not far from busy Orchard Road, where most of Singapore's best shopping centers parade their goods, stands this dilapidated hotel. It was once a landmark for foreign businessmen and locals to gather to enjoy evening drinks and dancing, but now it's in a sorry state and is only patronized by sailors who spend a few nights here before their ships set sail again.

Sketching and scratching

I made this sketch in the company of a swarm of mosquitoes and other insects as well. I had to work fast, sketching and scratching at the same time. Notice that although some of the lines are crooked, I did manage to complete the sketch in between the scratching.

Action Plan!

- Simplify and unify a complex scene.
- Deal with blank, uninteresting areas.
- Handle light and shade carefully.
- Introduce atmosphere, mood and character.

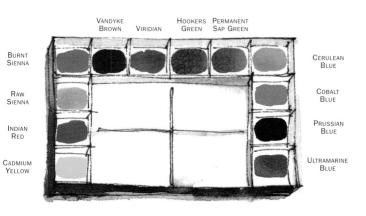

VANDYKE BROWN VIRIDIAN HOOKERS GREEN PERMANENT SAP GREEN

BURNT SIENNA

RAW SIENNA

INDIAN RED

CADMIUM YELLOW

CERULEAN BLUE

COBALT BLUE

PRUSSIAN BLUE

ULTRAMARINE BLUE

Applying washes all over the painting

I began with the building by mixing Ultramarine Blue with Raw Sienna, and fusing it with a mixture of Cobalt Blue and Burnt Sienna towards the bottom half of the painting.

I left a narrow space between the grass verge and the building for the steps leading to the entrance of the hotel. For the grass in front of the building, I washed with Hookers Green and Cadmium Yellow. Drops of Burnt Sienna, Permanent Sap Green and Raw Sienna were added to the grass color wash. For the sky, I used Cobalt Blue mixed with a little Ultramarine Blue, and I used Burnt Sienna with Ultramarine Blue for the dark areas of the clouds. Some parts of the paper were left white to depict highlights in the clouds.

Dealing with blank spaces

Using the remainder of the grass color mixture, I painted the leaves of the trees in front of the building. You will notice that there is just the building and nothing else to draw the viewer's attention. So the leaves were added to lead the viewer towards the building and also as a softening measure to avoid viewer confusion. I do this in many of my paintings to block blank spaces.

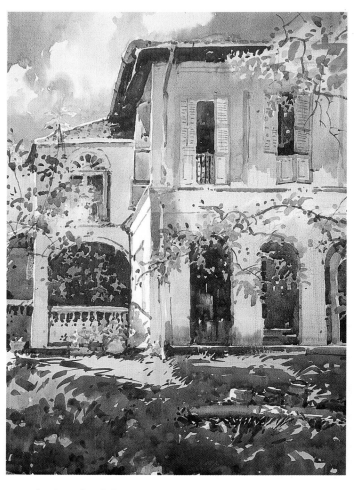

Introducing movement and accent color

After painting the leaves I concentrated on the shadows in front of the building. I worked with bold strokes to produce movement in the grass. To give variety to the grass colors I added orange, Cerulean Blue, Indian Red and Viridian to the color of the shadows, which was made up of Hookers Green and Vandyke Brown. The piece of log and some pails in the foreground were painted with earth colors so they did not overshadow the grass patch. The shadows on the building (a mixture of Cobalt Blue and Raw Sienna) were painted at this time. I added the roof with a mixture of orange and Burnt Sienna, and used Burnt Sienna, Ultramarine Blue and Permanent Sap Green for the underlying areas. The drainage pipe, a feature of Straits Chinese architecture, was added by using a darker value of the building shadow mixture (achieved by adding Cobalt Blue to the mixture).

Developing the foliage

I painted in the tree branches and the leaves in the shadow areas. Lines were defined in areas not so distinct, such as the steps leading to the hotel. Some highlighted areas of the grass verge were painted with sawtooth strokes in dark colors to project the edges of the grass.

The finished painting

For the finishing touches I added the dark areas using Ultramarine Blue and Prussian Blue. After studying the painting, I added a stroke or two on the grass patch and the building for balance.

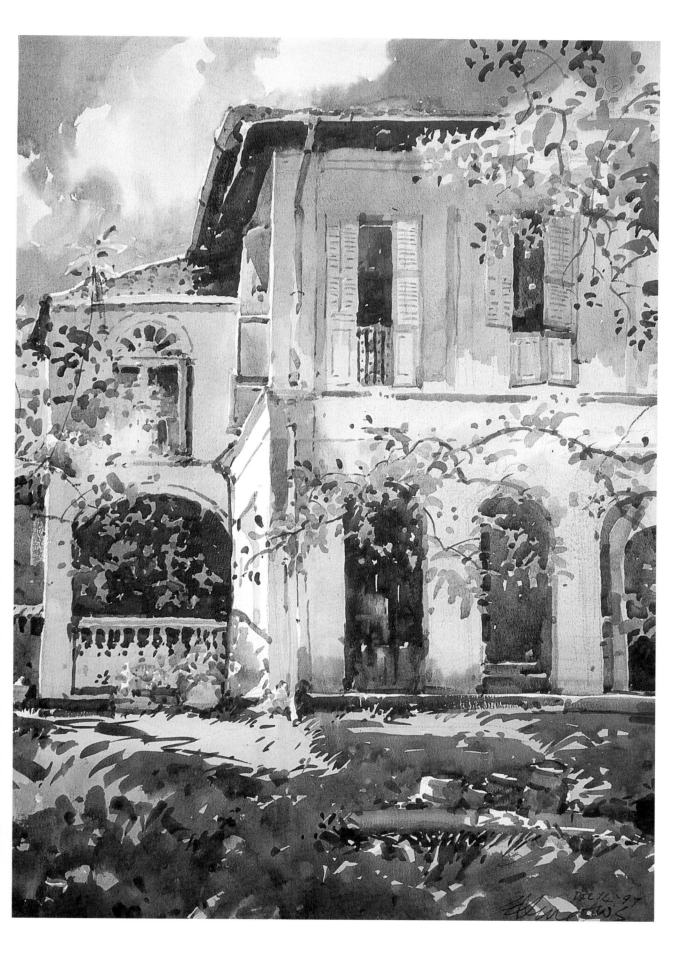

Action Plan!

- Capture the spirit of a famous setting.
- Control and simplify complex elements.
- Maintain overall balance and harmony without sacrificing tonal contrast.
- Suggest rather than over detail.
- Fuse color in less important areas.

The scene

Cityscape, Singapore

The buildings on the right of the photograph were built during colonial days. In the center is the High Court of Singapore and to the right, the Asian Civilization Museum. This is a scene very representative of Singapore because also in the center of this scene is a statue of Sir Stamford Raffles, the founder of Singapore. It approximately marks the place where Raffles first landed.

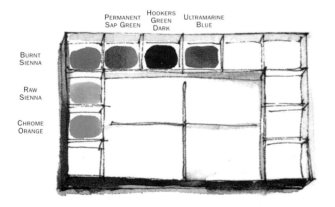

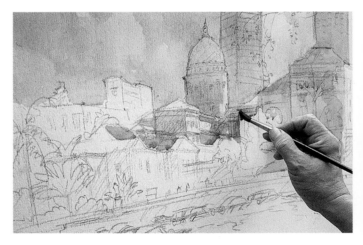

Developing the buildings

The buildings to the right of the Court were painted next with a warm mix of Chrome Orange and Burnt Sienna. For the roof I used a mixture of Raw Sienna and Chrome Orange, and for the façade of the buildings, a lighter shade of Raw Sienna.

he point of interest

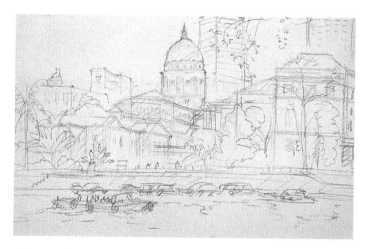

My pencil sketch
This is the completed sketch I made while seated between the two trees. I had to wait for a boat to motor past to include in the picture.

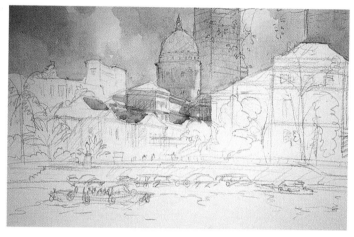

Making a start
I first painted the two buildings in the background and the sky. After that I indicated the dome of the High Court, then its structure, followed by the building near the Court and the roofs of the buildings surrounding it.

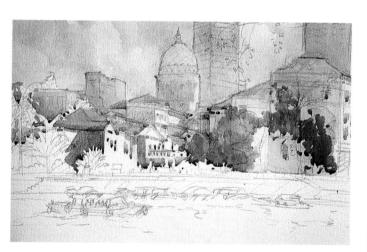

Introducing trees
I added an overlay of colors for the façade of the building in the center of the picture. For the dark colors I used a mixture of Ultramarine Blue and Burnt Umber. Then I introduced the trees using a mixture of Permanent Sap Green, Hookers Green Dark and Raw Sienna. To balance the composition I used a heavier tone for the lower part of the trees. I lightened the colors as I moved towards the center of the trees.

Detail
I maintained tonal harmony on the trees on the side wall of the building. ▶

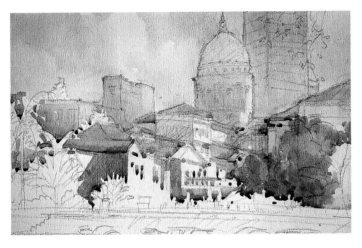

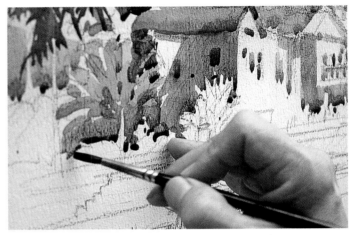

The story so far

Here's how the painting looked. I then moved on to paint the river and its bank. Notice the areas that I left white. Reserving areas allows me time to think. Once color is applied it is too late to do anything about it.

Detail

In this shot I was painting the palm trees along the river. Notice the shadow which established the angle of light. You must be consistent when working with shadows.

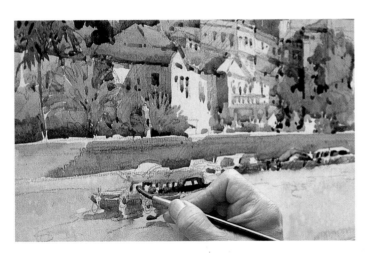

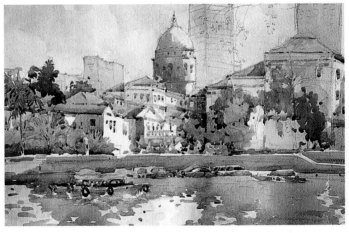

Modeling the boats

Every element has to have depth. Here I worked on the boat cabin.

Adding reflections and movement

I applied the first light washes representing the river water. Movement was suggested by the speeding boat cutting through the water.

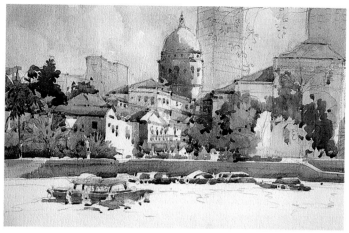

Fusing color

The shadows, palm trees and plants were all painted at the same time to allow the shadow and tree colors to fuse. I did this because I didn't want details to detract from the point of focus.

Re-evaluating progress

I worked on the dome of the High Court and then after the river bank was painted I stopped and examined the painting to check that overall unity was maintained, that tonal values and direction of light were correct and that no elements were out of balance. With my goal in mind I began work on the boats against the jetty wall and the foreground boat.

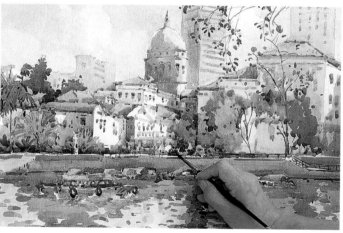

Enhancing the foliage

After studying the painting, I decided further painting of the trees was necessary to give them a better shape.

Adding darkest darks

Certain areas in the center, such as the shadows and parts of the buildings, needed to be drawn with clearer lines. I would normally emphasize the focal point of a painting by painting in the details or by using brighter colors to draw the attention of the viewer.

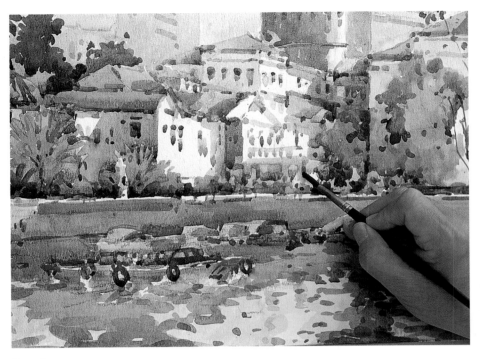

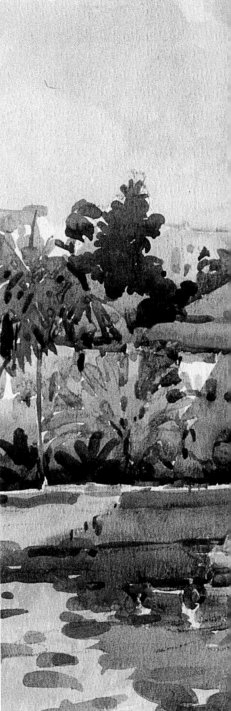

Framing

By including the foliage at the top of the painting I not only added interest but helped further the illusion of distance. Notice how I did not make architectural drawings of the structures, but there is enough information to trick the eye into believing they are correct.

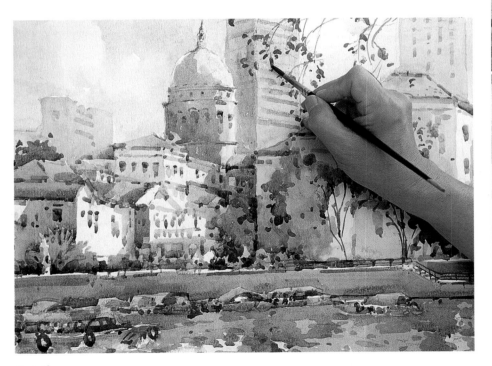

Detail

This shows the amount of detailing necessary to ensure that the painting had a full range of tonal values.

The finished painting
Anyone who has been to Singapore will recognize this scene.

The scene

Saman Tiga Temple, Bali

This temple lies not too far from the artist village of Ubud. The temple grounds are spacious and are surrounded by small village huts and huge trees. Not many tour groups come here because it is not as famous as the temple of the Elephant Cave or Basakih, the mother temple of Bali. There are many similar temples of this style, but they are not as big, or as peaceful for painting, as this one.

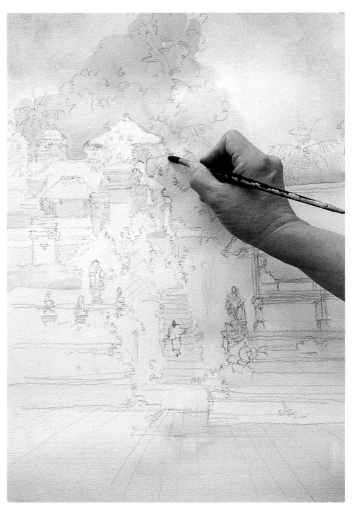

Making the initial drawing

I usually work with the board slightly tilted, which offers me a clearer view of the scene in front of me. I indicate the shadow areas by shading lightly. This acts as my map for laying in darker tones for the shadows. As for the highlighted area I put in a small "x" as a reminder to leave it white.

Action Plan!

- Make a shadow plan.
- Allow white paper to remain.
- Work with wet-in-wet washes.
- Maintain correct tonal value.
- Secure the focal point.

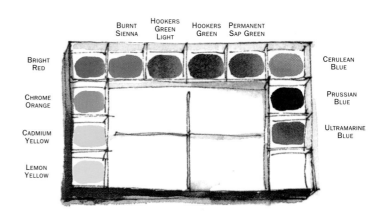

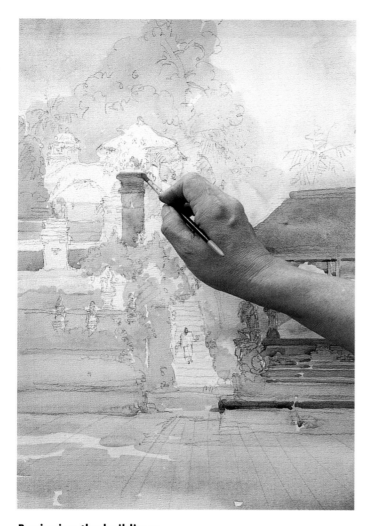

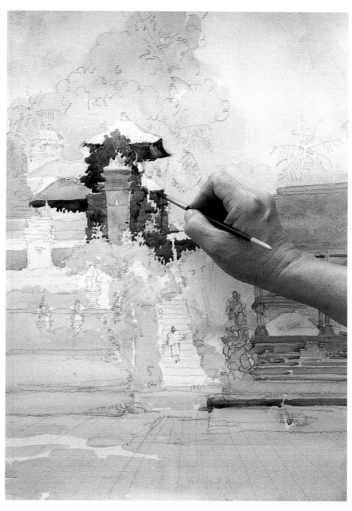

Beginning the buildings

After wetting the sky portion I painted from top to bottom. This enabled me to start painting the distant trees using the wet-in-wet method. While doing this I was careful not to get colors onto the sides of the buildings.

Next, I wet the areas below the sky and put in a wash of a mixture of Raw Sienna and a little Permanent Sap Green for the foreground to establish a base color for the ground later on. At this stage the paper was fully wet on the surface, so any additional colors would bleed.

I painted in the darker areas of the doorway. I tried to use colors as close as possible to the actual Balinese temple colors, because I find it important and interesting to adopt some of their artistic qualities. When I paint overseas I like to study the colors of dresses, curtains, painted doors, furniture and all the objects peculiar to each country.

Developing the temple structure

I painted the roof and another structure by the doorway. I still used the same basic colors for the ceiling of the archway. However, since it was some distance away from the doorway, I added in a large amount of water to make it lighter. The man coming down the steps was painted with a very light wash of Bright Red and his sarong in Light Yellow with a little Cerulean Blue. Placing the figure correctly is vital in a scene like this.

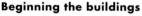

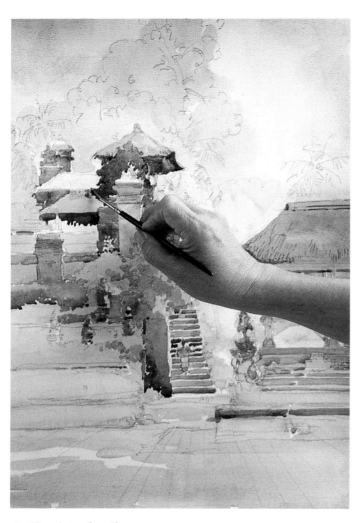

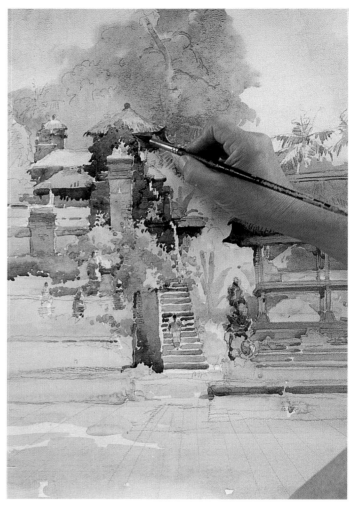

Getting into details

Using a smaller brush I painted the details in the focal point. Since I had dark initial washes I had to mix a color that was much stronger — a combination of Ultramarine Blue and Burnt Sienna. The side pillar of the wall to the doorway should be very prominent in the painting. I had to project this as the second object of importance.

Adding the figure

I added trees and plants around the buildings. In Bali the land is lush with a rich variety of tropical plants. Sometimes I felt I was lost in a green dream world. This is a land where I can study the innumerable shades and variations of green. For the tree nearest to the steps I used a mixture of Lemon Yellow with light green for the lighted areas and a mixture of Sap Green and Raw Sienna for the shadow area. For the grass verge of the steps and the pillars, I mixed Cadmium Yellow and Hookers Green Light.

I checked to see whether some important areas have been painted over by mistake, and corrected immediately. I added the details for the statute and the offerings stage. I used a small brush for the shades and at times the dry brush technique for the cracks on the wood surface. The open ground in front was left as empty as possible to lead the viewer's eye to the man coming down the steps as well as the doorway.

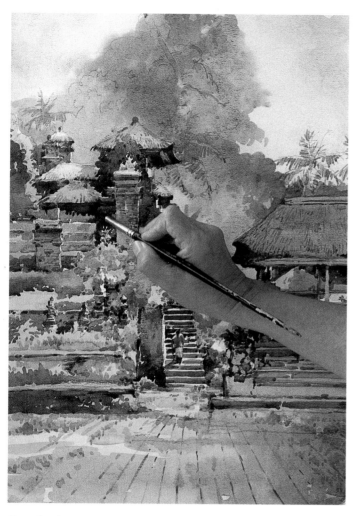

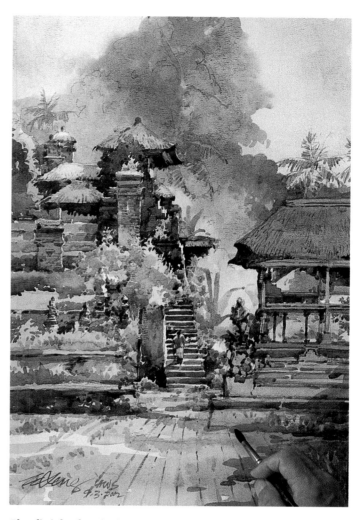

Developing contrast

The plant shadows were painted with a mixture of Permanent Sap Green and Burnt Sienna. For the darker tones of the stage, I applied a mixture of Ultramarine Blue and Raw Sienna.

To be able to complete a painting on location is always an accomplishment, especially in tropical heat when being bitten by mosquitoes.

The misty effect on the banana tree at the foot of the entrance was painted using a mixture of a very light Raw Sienna and Hookers Green Light. I add a little Burnt Sienna to the mixture of Raw Sienna and Hooker's Green to show the weight of the banana leaves.

The finished painting

I completed the painting by putting in the shadows. There is a huge Banyan tree on the right side of the buildings that cast a strong shadow on the foreground but I decide not to make the shadows too strong as they may overshadow the focal point in the center of the painting. To balance the composition I check the colors as well towards the end of the painting. I added a thin wash of Burnt Sienna and Prussian Blue for the base of the stage to balance with the colors of the doorway.

Using everything we know to paint

This painting is of Bode, a remote town near the Nepalese Tibetan border. My intention is to show you in many steps how I completed this painting. Following every step in the making of this painting will enable you to get to know the process and techniques I applied in my Nepali paintings, many of which have won awards at international art exhibitions.

Action Plan!

- Make a detailed drawing.
- Plan the base washes.
- Fuse color to prevent dull flat areas.
- Control color.
- Manipulate the brush.
- Apply detail strategically.
- Use the optimum tonal plan.
- Use color in the shadows.
- Enhance the light with darks.
- Define the focal point.

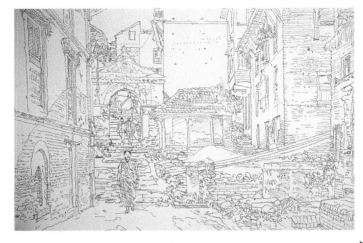

Making an accurate but edited drawing

First I sketched the scene in great detail but at the same time I eliminated elements that did not suit the atmosphere of the painting, for example, ugly billboards, motorcycles and cars, telegraph poles, electrical wires hanging dangerously, fashionably dressed tourists, and even graffiti on walls. I believe that these things do not fit into a well-focused painting.

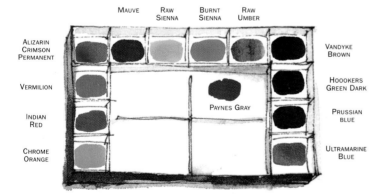

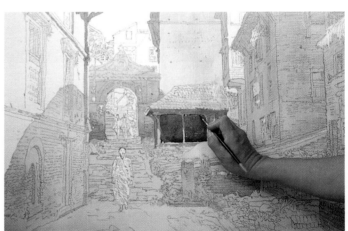

Introducing some darks

I mixed Burnt Sienna and Ultramarine Blue for the interior of the shed. Painting from top to bottom I fused the mixture with Hookers Green Dark, Alizarin Crimson and Prussian Blue.

omplex scene

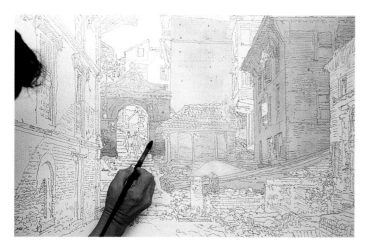

Laying a base wash

Using a mixture of Chrome Orange, Burnt Sienna, Vermilion and Raw Sienna I laid a wash on the areas that I wanted to focus on later. To me this is the most interesting part of the painting. The wash must be well diluted so that the flow is even. Do not be afraid of the paint running into areas not meant to be colored or destined for other colors. This can be corrected with a hard, dry brush ready at hand. I use a nylon acrylic painting brush for this purpose.

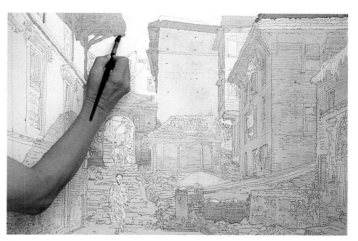

Continuing the initial washes

Once the wash for the arch was laid, I applied the base color for the rest of the painting, using a much more diluted combination of the four previous colors. I added a bit of Ultramarine Blue to this combination for the roof on the left and the roofs of the buildings on the right.

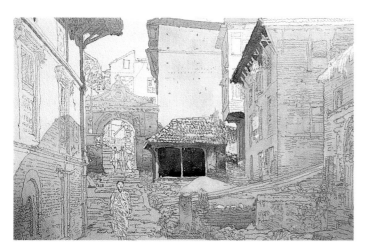

Taking control

I laid a wash of dark Burnt Sienna and Ultramarine Blue for the underside of the roof support of the building on the right. Using this method I would be able to control the areas leading to the focal point without further duplication.

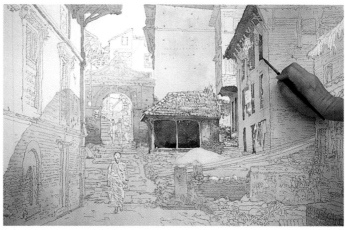

Manipulating my brush

Using the dark mixture of Ultramarine Blue and Burnt Sienna, I painted the windows. Notice that I put different degrees of pressure on one stroke — the pressure on the top of the window is heavier than that at the bottom.

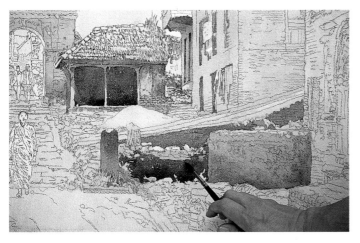

Fusing color

The darker side support of the wall was painted with a mixture of Mauve and Raw Umber fused with Ultramarine Blue.

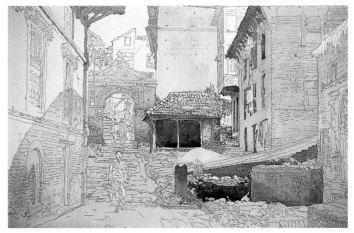

Detail

The story so far.

Modeling the windows

The sides of the window and window sills were painted using the side wall colors. The lines for the shadow area of the window were painted with a darker tone.

Applying a strategic glaze

Using a mixture of Vandyke Brown and Hookers Green Dark, I laid a glaze to the wall leading to the house at the end of the flight of steps.

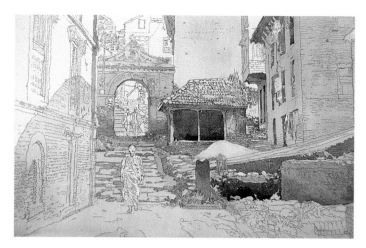

Developing shapes

With the same mixture of Mauve, Raw Umber and Ultramarine Blue I painted the curve of the archway.

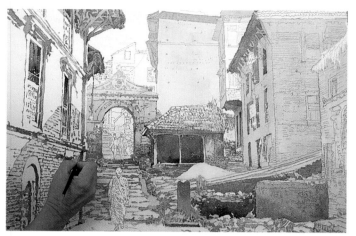

Controlling detail and tone

It was important to gauge the amount of detail required at this stage. I painted the rock and the brickwork on the left, where I drew lines in more detail. I continued with the doorway using the same colors as for the bricks, but added Hookers Green Dark. I added some Mauve and Ultramarine Blue when the color thinned off. The side of the wall and drainpipes were painted.

Getting into the background

With a diluted mixture of Paynes Grey, Prussian Blue and Raw Sienna I painted the house in the background.

Coloring the dress

I added another glaze over the colors I applied for the walls on the side leading to the house in the background.

The woman's dress was painted with a mixture of Vermilion and Indian Red. I left the shadows for later. Details were added to the gap between the house on the right and the shed in the center.

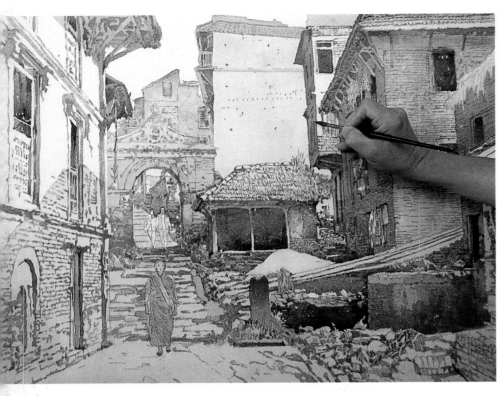

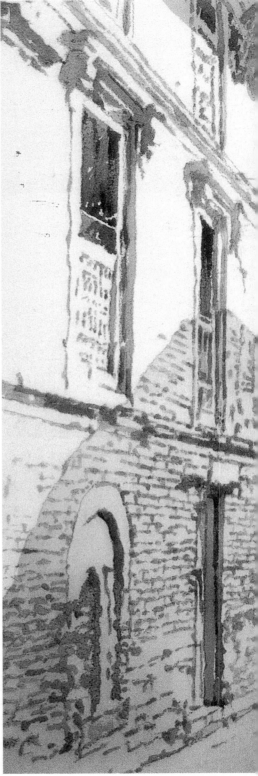

Developing the structures

With a mixture of Raw Sienna and Chrome Orange I painted the roof of the house on the left. The details of the brickwork on the side wall of the building on the left were painted and I developed the structures on the right.

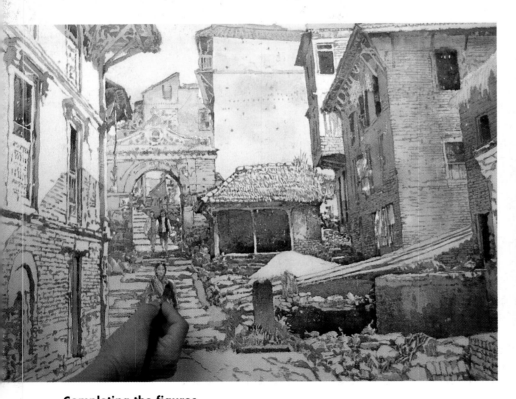

Completing the figures

I complete painting the three figures in the painting, including the crinkles on the woman's dress.